W9-ADL-827

IMAGES
of America

THE NYACKS

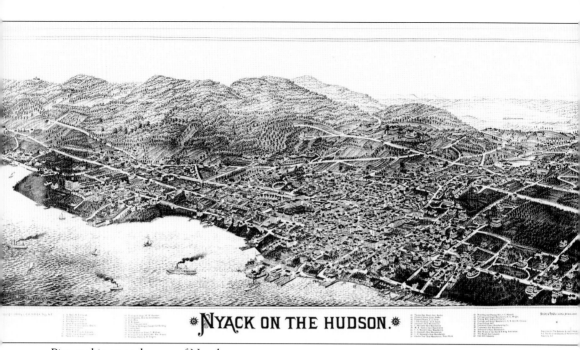

NYACK ON THE HUDSON.

Pictured is an early map of Nyack.

IMAGES
of America

THE NYACKS

Historical Society of the Nyacks
and Nyack Library

ARCADIA

Copyright © 2005 by Historical Society of the Nyacks and Nyack Library
ISBN 0-7385-3805-1

Published by Arcadia Publishing
Charleston SC, Chicago IL, Portsmouth NH, San Francisco CA

Printed in the United States of America

Library of Congress Catalog Card Number: 2005921533

For all general information contact Arcadia Publishing at:
Telephone 843-853-2070
Fax 843-853-0044
E-mail sales@arcadiapublishing.com
For customer service and orders:
Toll-Free 1-888-313-2665

Visit us on the internet at http://www.arcadiapublishing.com

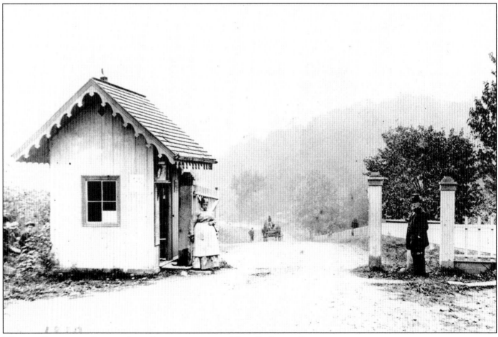

This tollgate was located at the entrance to Nyack from the west.

CONTENTS

ACKNOWLEDGMENTS

We wish to thank the many people who have made this book a reality: Mary Bookbinder, Sally Cunneen, Bob Goldberg, Tick Litchfield, Ken Kral, and Gini Stolldorf, who spent long hours in the Local History Room of the Nyack Library researching our captions; Haydie Verdia, Empire State College intern, who provided expertise on layout and digital imaging; the staff of the Nyack Library, including Carol Weiss, Carolyn Kent, and historian Denning McTague, who scanned our photographs; Sally Cunneen, our editor; and Jean Pardo, Win Perry, and Myra Starr, who checked our manuscript and made helpful suggestions. We are most grateful to Jim Mahoney, director of the Nyack Library, who made the photographs of the Nyack Library Local History Room available to us. The photographs include those from the Stockmeyer collection, the John Scott collection, the Historical Society of Rockland, the Win Perry collection, the Noel Oursler collection, the Lydecker collection, the Helmke collection, and the Zabriskie collection, and photographs by Sally Savage and Fred Burell.

—Evelyn Fitzgerald and Leontine Temsky
Cochairs, Historical Society of the Nyacks publications committee

Salisbury Manor is shown in this rendering.

INTRODUCTION

The Nyacks are uniquely located on a shelf of land below mountains to the west, north, and south along the west side of the Hudson River 20 miles north of New York City. The mountains and the West Nyack swamp isolated the village from the interior of Rockland County, and the only passable routes were along the shore southward to Tappan and over the western hills to the King's Highway, an early north–south road that passed east of the swamp, leading to Tappan or Haverstraw. Nyack's story is culturally varied and historically rich.

Nyack was given its name by the Nyacks, a subgroup of the Lenni Lenape, speakers of the Algonquin language, who lived here in the mid-1600s. The tribe's ancestral home was Coney Island, a point of land on the south side of Brooklyn, and the word Nyack means "point of land." They moved to the place that now bears their name under pressure of Dutch settlement in New Amsterdam and Long Island. In 1657, the sachems of Haverstraw, Nyack, Tappan, and Hackensack signed a deed to Staten Island, from which we infer that they had already made the move. Unfortunately, they did not stay long, for in the 1670s they were already deeding land here to the settlers.

In 1671, some 640 acres of land were patented to Claus Jansen (Cooper) by Governor Carteret of New Jersey. A portion of this land was sold around 1675 to Dowe Tallman, whose son Harmanus became the first white settler in what is now the whole of Rockland County in 1675. His "New Orange trading camp" was located in what is now the business section of Nyack. Many generations of Tallmans occupied a farmhouse that stood at the northeast corner of Broadway and Tallman Place. The Tallmans built a mill along the brook that now flows by and under Main Street. Cornelius Cooper (or Kuyper), son of Claus Jansen, settled in what is now Upper Nyack. Cooper served as sheriff, justice of the peace, colonel in the militia, and member of the colonial assembly. Theunis Tallman, son of Dowe, became high sheriff of Orange County, which included Rockland County at the time, and also owned and operated a large farm. The boundary between their farms became the border between Clarkstown and Orangetown.

During the Revolutionary War, Nyack was a frontier post between the opposing forces. The British made two attempts to land here in 1776 but were repulsed by locals serving in Col. A. Hawks Hay's shoreguard militia. Tory marauders attacked the home of Michael Cornelison in South Nyack on a foraging expedition, and in Upper Nyack a galley putting ashore for provisions was rebuffed by patriots. A swivel gun in Upper Nyack was used with considerable effectiveness. Nearby, significant action took place at the Battle of Stony Point, the forging and placement of an iron chain across the Hudson near West Point, and the capture, trial, and hanging of British spy Maj. John Andre in connection with the attempted betrayal of West Point by Benedict Arnold.

At the end of the Revolutionary War, the Nyacks consisted of a few dozen farms and a population of fewer than 500. As the economy grew more complex, farmers took on more specialized roles as millers (saw and grist), blacksmiths, and storekeepers and even developed a growing cottage industry of shoemaking.

By 1799, heir Abraham Tallman sold most of his land to Abraham Lydecker. Tunis Smith came to Nyack in 1810, bought land, and built a house at the foot of Burd Street. About 1812, his neighbor John Green built a house that still stands at the foot of Main Street. Both built docks, engaged in shipping, and had retail businesses in the growing community. Most of the first settlers were of Dutch ancestry, and they were soon joined by English, Scottish, Irish, and other arrivals from Europe. Some of the settlers owned African slaves, and two early owners in the Tappan Patent were free blacks.

Slavery came into Nyack with the first settlers; slaves labored as farm hands and domestic workers. In 1800, there were about 550 slaves in Rockland County. Gradual emancipation followed New York State's passage of a law banning the purchase and sale of slaves in 1827. Before the Civil War, Nyack is reputed to have been a station on the Underground Railroad, with at least one safe house assisting escaping slaves from the South in their journey to freedom in Canada.

As it grew in the 19th century from a small hamlet to a sizeable village, the community became the commercial center of the surrounding farmlands. Its growth was directly related to its role as a transportation hub in the economy of the region. At first, Nyack was a boat landing for passenger travel and the shipping of sandstone and farm produce, and the Hudson River provided its primary contact with the outside world. The road leading to Tappan allowed people to make a strenuous trip to church or the county court by horseback or buggy. In 1825, when the Nyack Turnpike was opened leading west from Nyack's Main Street to Suffern, it became a major lifeline to the land behind the mountains. The arrival of the railroad in the mid-19th century hastened industrialization near the tracks, providing a convenient commute to New York City and generally enhancing the prosperity of Nyack.

By the 1870s, a number of neighborhoods had attained the configuration that continues today. A few luxurious houses were built by wealthy landowners, among them successful industrialists such as James Thompson, Azariah Ross, and Henry E. Storms. More modest homes were also built to house ship carpenters, businessmen, factory workers, and professionals. Less expensive neighborhoods provided the opportunity for working-class families to own homes of their own. This architectural mixture is a dominant feature of Nyack today.

Until the latter part of the 19th century, Upper Nyack was governed by the Town of Clarkstown and Nyack and South Nyack by the Town of Orangetown. The three Nyacks later voted (in the 1870s and 1880s) to incorporate as separate villages. By the mid-19th century, Nyack had become a resort for residents of nearby New York City seeking cleaner air and water and more space than they were accustomed to in the city. Hotels sprang up in town and beyond.

Today the hotels are gone. There are apartments in some of the gracious old homes and in newer brick buildings along the waterfront. Nyack has become a restaurant and antique center featuring street fairs and parades and a number of thriving small businesses. Today it boasts three theaters, a film society, several art galleries, coffeehouses, and a farmers' market. Nyack retains its architectural charm and variety as well as its easy access to the beautiful Hudson River.

One

THE RIVER

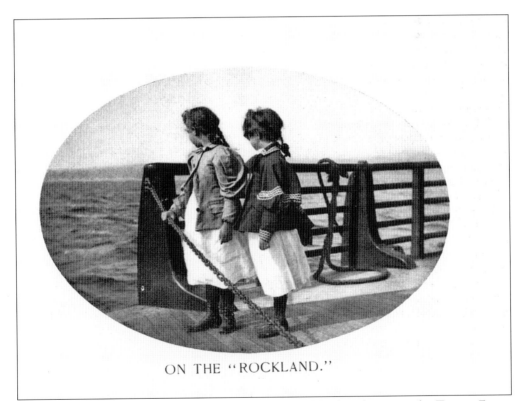

ON THE "ROCKLAND."

Two young girls stand on the deck of the ferryboat *Rockland* as they cross the Tappan Zee to Tarrytown in the early 1900s. For youngsters of that era, a trip on the boat was an exciting adventure that sometimes included an accordion player. Such a trip might be followed by a ride on the trolley to White Plains to shop in its great stores. Ferry service across the river began in 1834 with a small sailboat named the *Donkey* and continued until the opening of the Tappan Zee Bridge in 1955.

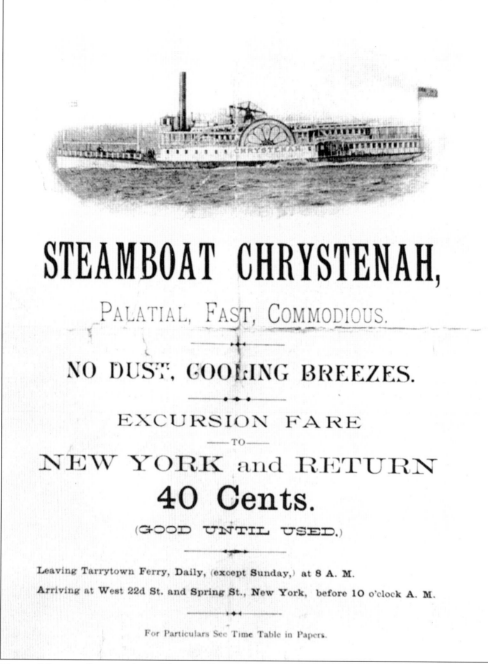

Pictured here is the steamboat *Chrystenah*.

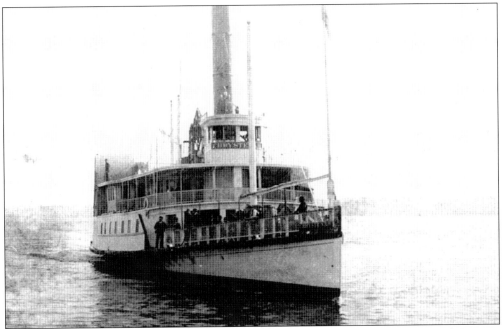

The steamboat *Chrystenah* was built in Nyack for a well-known Nyack family, and for over 50 years, it was the favorite riverboat of the lower Hudson River. It was named for the mother of the owners, Chrystenah Smith, and her portrait hung in the main salon. The boat sailed from Peekskill to New York City, stopping at several villages along the way. On occasion, Nyack passengers were boarded and discharged in the middle of the Tappan Zee, where the *Chrystenah* met the ferryboat *Rockland*. The trip from Nyack to the city took two hours, with the arrival scheduled for 10:00 a.m.

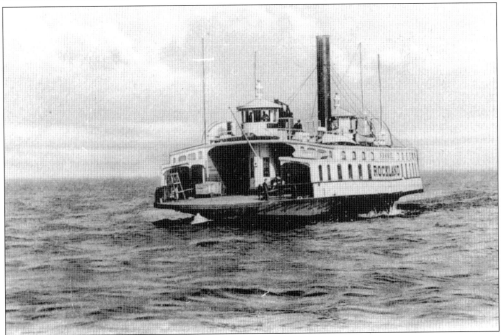

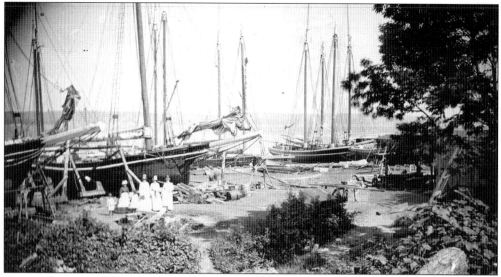

During the early 19th century, Nyack boatyards produced more Hudson River sloops than any other port along the river. The early success of Nyack's quarries created a need for ships and barges to carry the rock products of many quarry sites, from South Nyack to Hook Mountain. Eager to exploit new technology, Nyack shipbuilders pioneered the use of centerboard sloops to modify the old Dutch-design sailboats with their cumbersome leeboards. After the Nyack Turnpike was completed in 1825, more ships were needed to carry the products of inland farms to markets in New York City. The South Nyack shipyard of Henry Gesner built the steamboat *Nyack* in 1826. During the rest of the 19th and early 20th centuries, Nyack boatyards produced many steamboats and some of the finest luxury yachts for America's wealthy yachtsmen. Two- and three-masted schooners like those pictured replaced sloops because their smaller sails required a smaller crew, giving them an economic advantage in the competition with steamers.

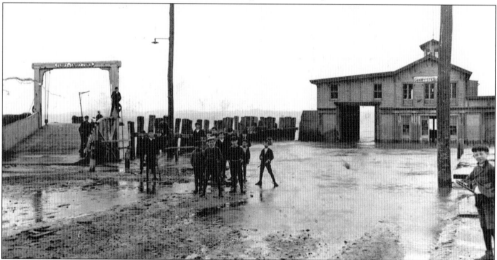

This 1902 waterfront scene shows the landing of the Nyack-Tarrytown ferry and the dockside building used by the passenger steamboat *Rockland*. The arrival of the ferry was always a big event for Nyack youngsters. Ferry service ended in 1955, and by the late 1960s, the site had a motel and restaurant, a marina for pleasure boats, and several fancy shops. Today it is the location of a luxury condominium.

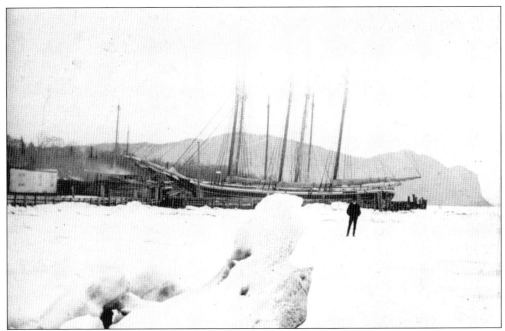

After the Hudson River froze in the winter, most marine activities came to a halt. Ferry service stopped, and boats were secured at their berths or hauled out of the water. This view of the Smith boatyard, along Gedney Street near Third Avenue, shows several large sailing vessels berthed for the winter.

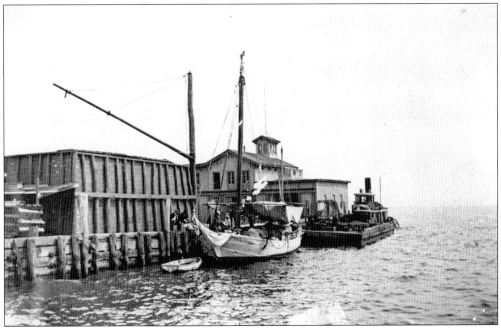

This photograph from the early 1900s shows the old pier at the foot of Burd Street, where a commercial sailboat, a barge, and a tugboat are docked. The *Chrystenah* would also use this pier when it docked in Nyack. The sailboat is the *Spray*, in which Capt. Joshua Slocum sailed around the world alone between 1895 and 1898.

Julius Petersen was a prominent Nyack boatbuilder and shipyard owner. He arrived in this country in 1890 as a 23-year-old immigrant from Denmark and began his shipbuilding career in Staten Island. During the Spanish-American War, he moved to Tarrytown, where he established his own shipbuilding business. Nine years later, he moved to Upper Nyack and took over the former Van Houten boatyard. Here he established his reputation as a builder of fine luxury yachts for wealthy clients. During World Wars I and II, the yard produced submarine chasers and aircraft rescue vessels for the military. Petersen died in 1949 at the age of 81, but the boatyard is still in operation.

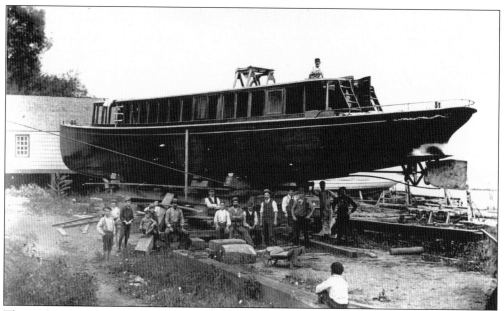

The yacht *Gracie*, built in Nyack in 1868 for Commo. William Voorhis, was said by some to be the swiftest boat of its kind in the nation. In 1871, it competed unsuccessfully to be the defender of the America's Cup. John Jacob Astor and Commodore Vanderbilt commissioned several luxury yachts from Nyack shipyards. This early-20th-century photograph shows one under construction. Note the young boys among the workers, and the derby hats, white shirts, ties, and dress vests worn by several workers.

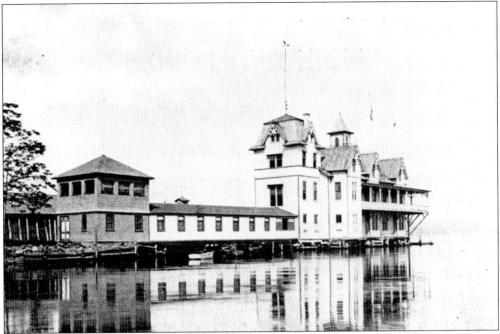

In 1882, the Nyack Rowing Association built this magnificent clubhouse over the Hudson River at the foot of Spear Street. Its members included the cream of Nyack society, who shared a love of small boat outings on the river. The boathouse contained a 34- by 60-foot ballroom, two huge fireplaces, a 90-foot gangway, a large crystal chandelier installed below a domed ceiling, and many other luxurious features. In the 1890s, the club experienced hard times and was subsequently sold to Julius Petersen's boatyard. It was badly damaged by a hurricane in 1938 and finished off by a storm in 1950.

This idyllic setting along Gedney Street was once a center of Nyack's shipbuilding industry. By the early 20th century, the Smiths and many other boatbuilders were gone. In the 1960s, large high-rise apartment buildings, including Rivercrest and West Shore Apartments, were erected on the waterfront.

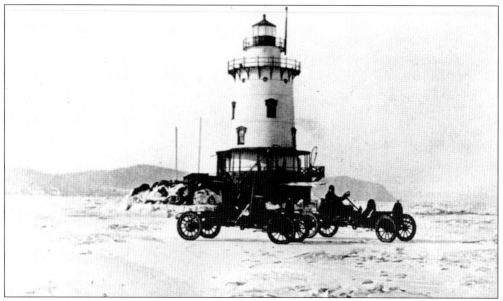

In the years before the Coast Guard opened the channel, the river would freeze over in the winter, and boats would abandon the river. Nyackers would walk and ride across the frozen Hudson. This c. 1914 photograph shows the Kingsland Point lighthouse near Tarrytown with a pair of open racing cars. Ice-boating, ice-skating, and horse-and-buggy racing were also popular winter river activities. Commuters could walk or ride across the frozen river to Tarrytown and catch the New York Central train to the city.

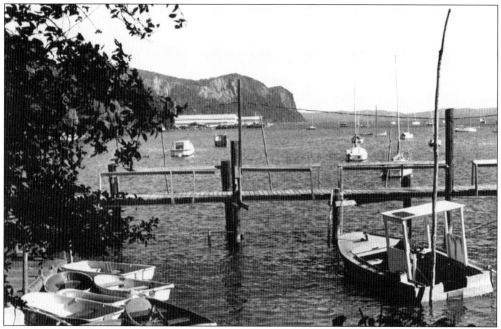

This riverfront photograph by Sally Savage shows the shoreline, looking north from the Hook Mountain Yacht Club. The large building near the center of the photograph is Petersen's Boat Yard at Upper Nyack. At over 700 feet high, Hook Mountain stands as sentinel in the distance.

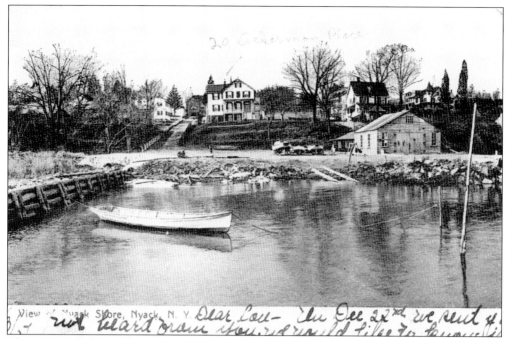

This postcard shows the Smith boatyard, located at the foot of Ackerman Place (now the Rivercrest Apartments).

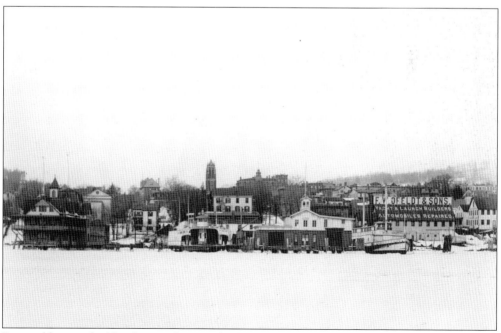

Pictured here is the Nyack waterfront at the foot of Burd Street.

This cover of a set of postcards from the early 1930s features a vignette of Hook Mountain.

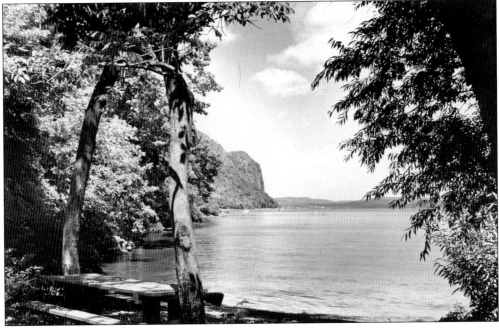

Hook Mountain is seen from the shore in Upper Nyack.

Two

VILLAGE LIFE

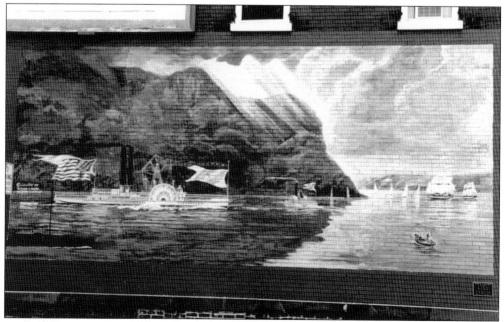

The mural *Yesteryear on the Hudson* was painted by Upper Nyack artist John Elliot on the brick wall at the corner of South Broadway and Burd Street. It was commissioned by the Friends of the Nyacks as a nostalgic visual reminder of the magnificent tall ships, sloops, schooners, steamers, and small boats that have enlivened life on the Hudson over the years.

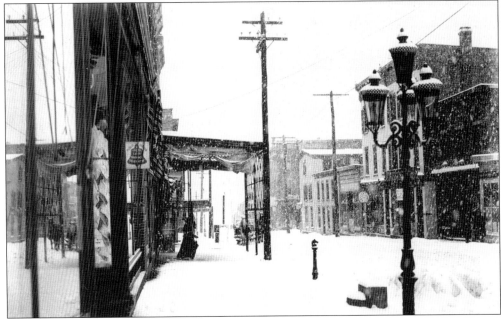

Falling snow adds charm to this photograph featuring buildings on the south side of Main Street west of Broadway around 1900. The building nearest the intersection of the two streets was torn down in 1908 to make way for the Rockland Trust Company. Note the hitching post, carriage mounting block, and early streetlight.

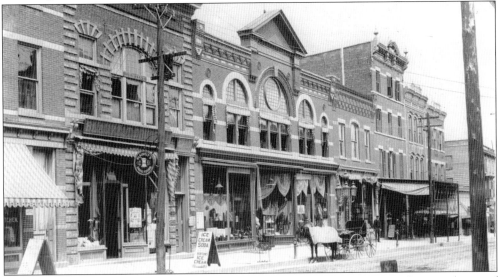

For many years, Nyack was the "commercial capital of Rockland County," with a population of 4,275 residents in 1900. A lively port on the Hudson, Nyack supported three daily newspapers, numerous doctors and lawyers, and many merchants. This view of the north side of Main Street shows a two-story building that was made of Haverstraw brick and was designed by Marshall and Henry Emery. The building was the home of the Harrison and Dalley department store, everyone's "city store in the country." The second floor housed furniture and other goods for the home, while the main floor carried clothing and all the other merchandise then deemed worthy of a fine department store.

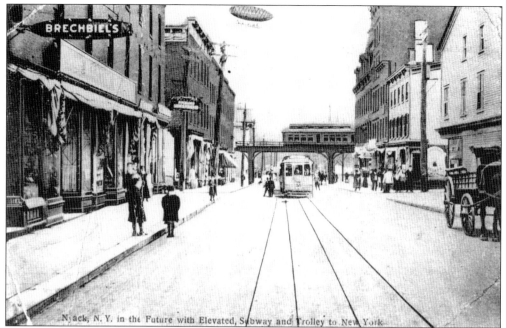

This fanciful old view shows a trolley on Broadway, an elevated railroad in the background, and a dirigible overhead. The artist superimposed them onto a photograph to illustrate transportation schemes proposed for the village. Nyack did give a franchise for a trolley to the Rockland Railroad Company in 1908, but it was never built.

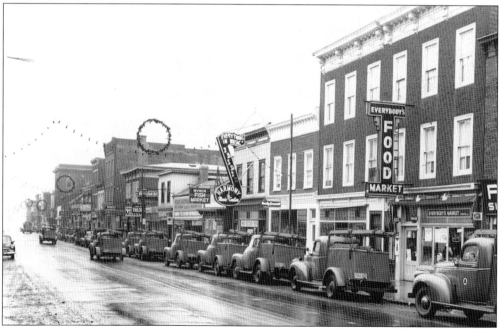

In this Lewis Stockmeyer picture, one sees the block on the south side of Main Street that was razed for urban renewal in the early 1960s. Some of the businesses that occupied this block were Everybody's Food Market, Harmony Music, Nyack Fish Market, and Nyack Hardware. Telephone company trucks line the street.

Three lanes converge into one at the intersection of Old Mountain Road and North Broadway in Upper Nyack around 1905.

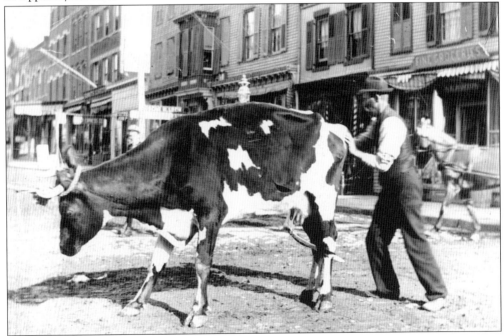

At the end of the 19th century, the Nyacks were the manufacturing, transportation, and business center of Rockland County, but the remnants of an agrarian society could still be seen in the 20th century. In this photograph from 1895, resident Del Howard is trying to move a cow away from the intersection of Broadway and Main Street, although the reason why remains a mystery to this day.

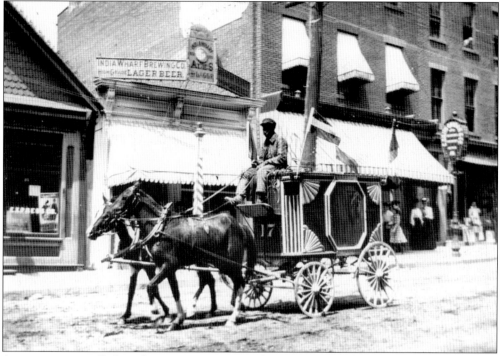

A circus wagon rolls by a few spectators on North Broadway. The small India Wharf brewery is in the background. Many small circuses visited Nyack during the late 1800s and early 1900s. The village required a license fee of 35¢ from each.

The First Baptist Church, at the corner of Broadway and Fifth Avenue, opened on January 12, 1882, in its present enlarged form. The founder and first pastor, Elder Joseph Griffiths, was the great-grandfather of 20th-century American artist and Nyack resident Edward Hopper. Three U.S. presidents are said to have visited the church: James Garfield, Grover Cleveland, and William McKinley.

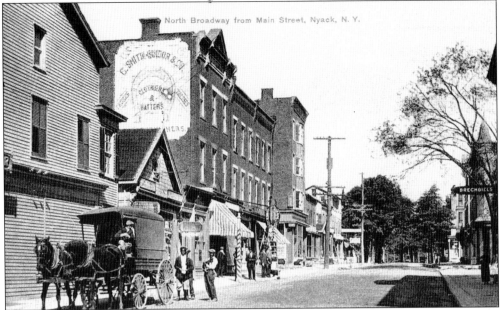

C. Smith Quidor and Company, "leaders in clothing, hats and gents furnishing goods," occupied the south side of the brick building at 9 North Broadway. Charles Smith Quidor came to Nyack in 1876 at the age of 14. For eight years, he worked for Robert Ziegel, a men's clothier, and then decided to open his store in 1884. Quidor was active in the Nyack community, serving as a volunteer fireman (Mazeppa Company), in the YMCA, and in other civic organizations.

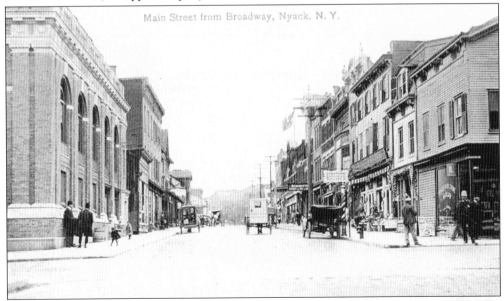

The automobile seems to have replaced the horse-drawn carriage in this postcard published by the Nyack Five and Ten Cent Store. Just up from the corner at 82 Main was I. Neisner, a men's clothing store, advertised as one of the most up-to-date such stores between New York City and Albany. Neisner came to Nyack in 1890. The sign for Schmitt's Candy and Ice Cream is clearly visible on the right side of the street. Schmitt delivered ice cream to local homes and returned later to pick up the containers.

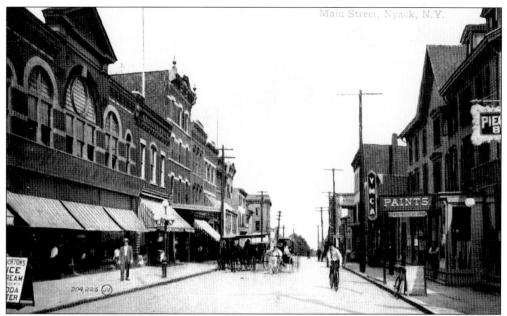

The Harrison and Dalley department store can be seen on the left side of Main Street. On the right is the YMCA, which goes back to the 1870s in Nyack. In 1927, it got a building of its own, which still stands at 35 South Broadway.

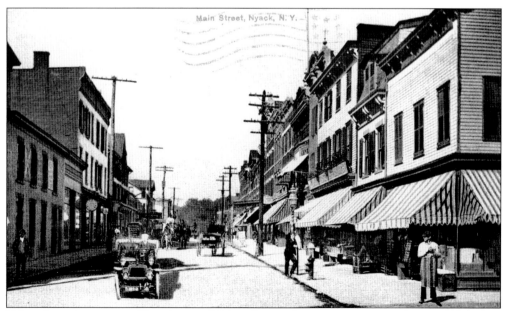

Taken from the corner of Broadway and Main Street, this picture was on a 2¢ postcard sent in 1918. A horse-drawn carriage competes with the automobile here. The "motorized carriage" caused anxiety to many horses, and state laws were written to protect the carriages. One of the earliest automobiles to ride on local streets was a vehicle driven by steam (like the Stanley steamer).

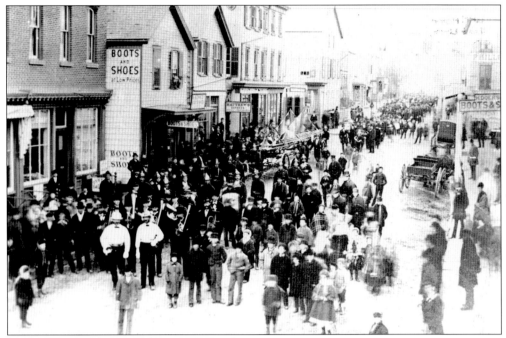

This is a view of the annual Firemen's Parade.

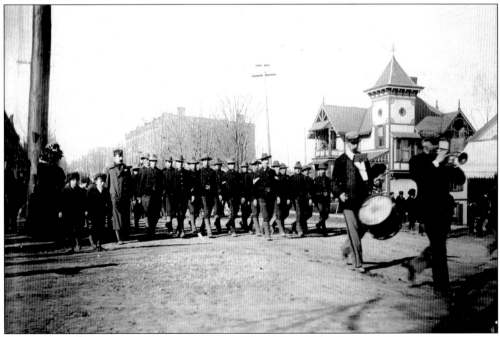

In 1913, Spanish-American War veterans parade south on Broadway past Cedar Hill Avenue.

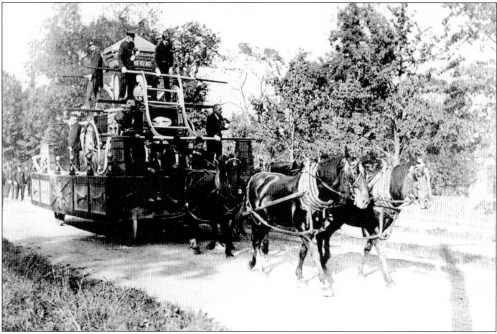

This is a hand pumper on a float in a parade.

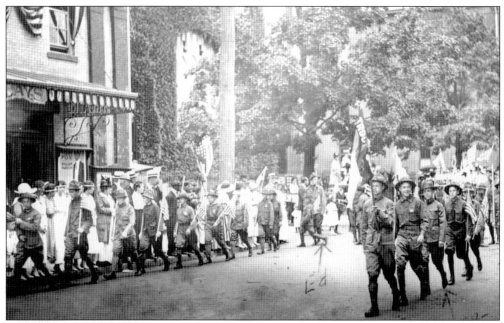

Boy Scouts march along Broadway in front of the Broadway Theatre, now demolished, and the Reformed Church in a pre–World War I parade. Note the high-buttoned shoes worn by the women on the sidewalk.

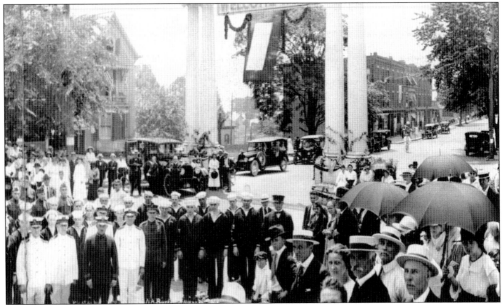

Soldiers, sailors, and townspeople stand at attention for the Fourth of July parade after the end of World War I. The huge archway was erected on Broadway for the occasion. Cars and columns are bedecked with flags and flowers.

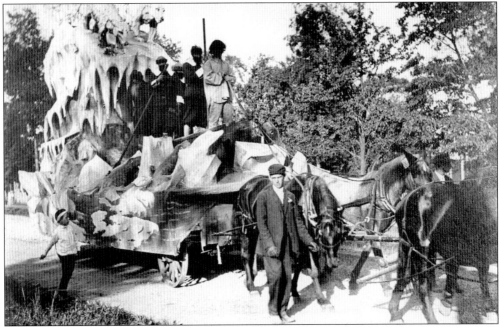

Firemen parade as a part of the Hudson-Fulton celebration in 1909. A number of firemen and an old pumper are on top of a large flat wagon drawn by four horses. Some see a mountain with two dogs, and some a boat with several bearded mariners surrounded by marine mammals. Take your pick.

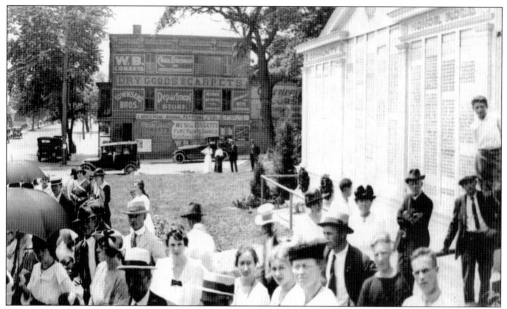

This is part of a large panoramic photograph of the July 4, 1919, celebration. This section shows a World War I honor roll on the site where the post office now stands.

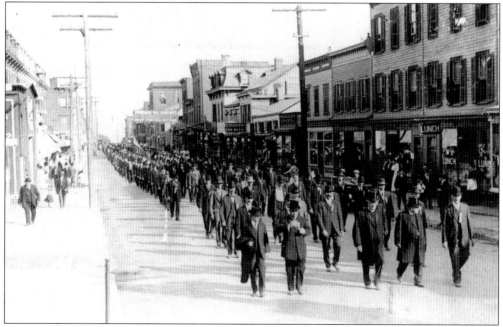

This is a parade in Nyack in 1901.

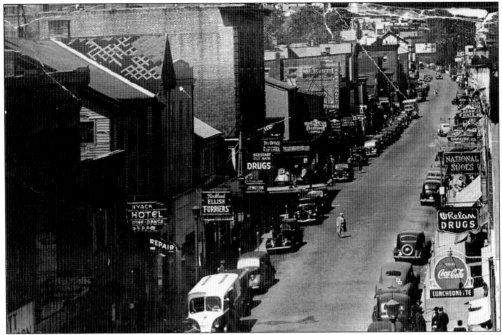

This view, looking westward, shows the south side of Main Street in the 1930s.

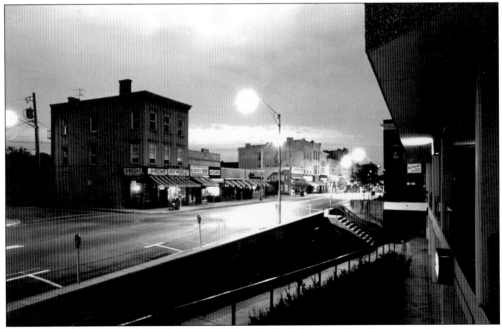

This 1984 nighttime photograph of Main Street at Park Street makes the street glow.

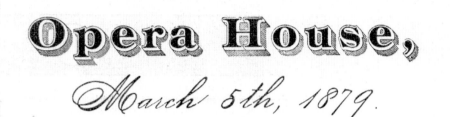

Opera House,

March 5th, 1879.

PROGRAMME,

—OF THE—

GRAND VARIETY

ENTERTAINMENT,

—TO BE GIVEN THIS—

Wednesday Evening, March 5th, 1879.

FOR BENEFIT OF

Fire Bell Fund.

NYACK, N. Y.

M. F. ONDERDONK, PRINTER, NYACK, N. Y.

This poster advertises an opera house benefit in 1879.

Nyack Philharmonic Society.

...

FIRST PUBLIC REHEARSAL

AT THE OPERA HOUSE.

On Friday Evening, October 4th, 1878.

...

•PROGRAMME.

SYMPHONY in C. Minor, No. 9 . *Haydn.*
 1. Alegro2. Andante Cantabile.
 4. Menuetto4. Finale, Vivace.
LIEDER OHNE WORTE (for Orchestra) *Parlow.*
OVERTURE "Jubel" . *Bach.*
SWEDISH WEDDING MARCH . *Soderman.*
RUSSIAN NATIONAL HYMN .

...

The first Concert will take place at the Opera House, Friday Evening, October 11th, 1878

Mr Arbuckle, the great Cornet Soloist, has been engaged for this occasion.

This poster announces a Nyack Philharmonic performance.

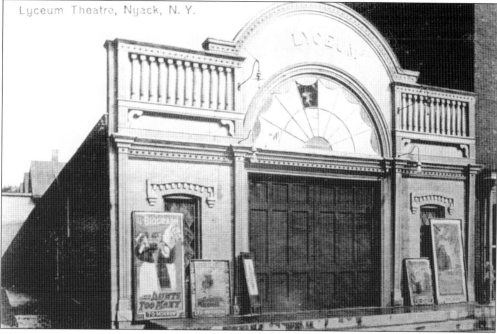

The Lyceum stood on the north side of Main Street near Franklin, next to Hawvermale Hardware around 1920. Later it was the site of a Grand Union supermarket.

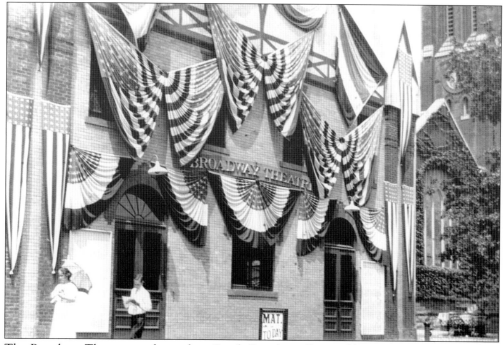

The Broadway Theatre was located on South Broadway. Pictured here in 1911, it was built in 1910 for vaudeville and motion pictures, both accompanied by live musicians. Competition from the new Rockland Theater a few blocks north closed the Broadway in the early 1930s. It later reopened for summer stock.

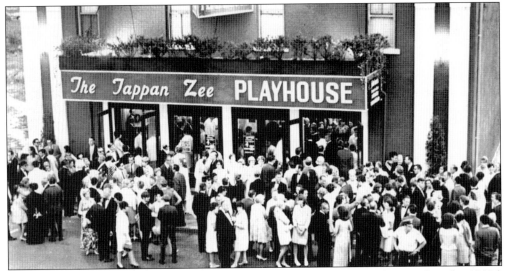

In 1958, the Broadway Theatre reopened as the Tappan Zee Playhouse (pictured in the 1960s) for summer theater. For years, it featured many stars, including Beatrice Lillie, Helen Hayes, and Jack Benny. After fire and hard times in the 1970s, it was bought by the nonprofit Tappan Zee Playhouse Association and renamed for local resident Helen Hayes in her presence. Despite efforts to refurbish the theater, it was abandoned in 1995 and soon razed to a shell of three walls. The Village of Nyack bought the site in the late 1990s and sold it to a developer, who tore the remaining shell down. There are current plans for this site to hold a food market with affordable housing for community volunteers above it.

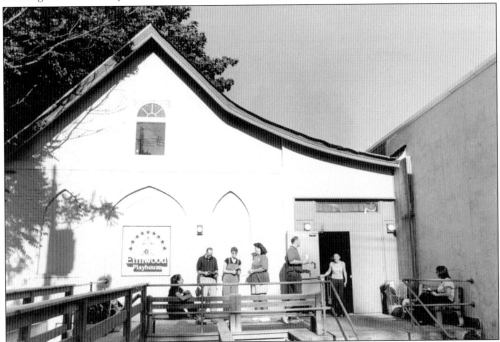

The Elmwood Playhouse opened in 1947 as a community theater. Its home is in this former Lutheran church on Park Street. Its creative run continues, using both amateur and professional local talent.

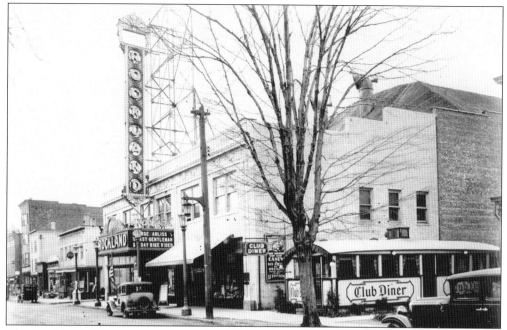

The Rockland Theater opened in May 1928 with 1,245 seats, the county's first $1 million building. Movie theaters then had balconies, pipe organs, and chandeliers, and this was no exception. The decor was Spanish. The theater closed its doors in 1967. It has been replaced by the Bradford Mews offices and apartments.

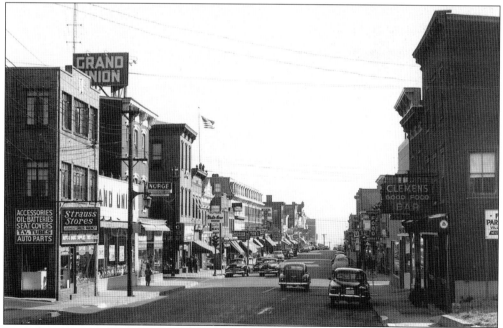

Main Street, west of Franklin, featured an automobile- and television-parts store called Strauss Stores, a Grand Union supermarket, and a household appliance store. The flag on the top of the building on the next block to the east identifies the Nyack Village Hall before it was relocated to Broadway in 1970.

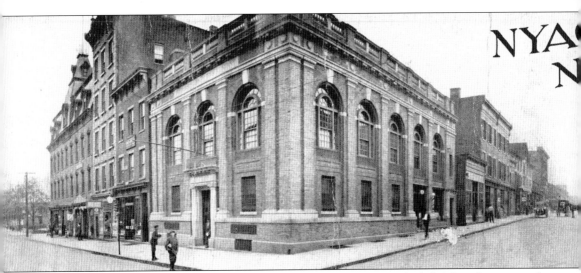

NYA
N

This panoramic view, taken about 1911, shows South Broadway to the left, Main Street straight

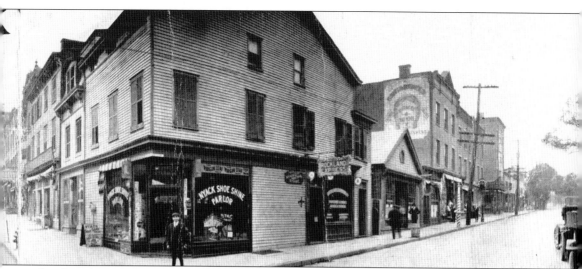

ahead, and North Broadway to the right.

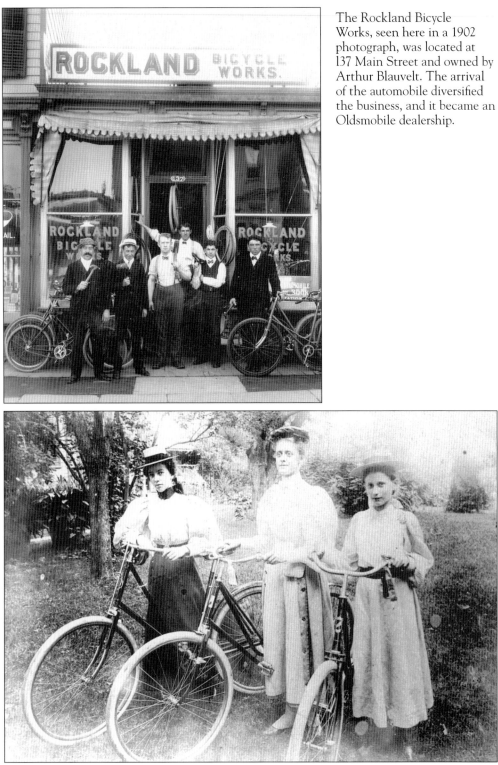

The Rockland Bicycle Works, seen here in a 1902 photograph, was located at 137 Main Street and owned by Arthur Blauvelt. The arrival of the automobile diversified the business, and it became an Oldsmobile dealership.

Girls enjoy bicycling in 1896.

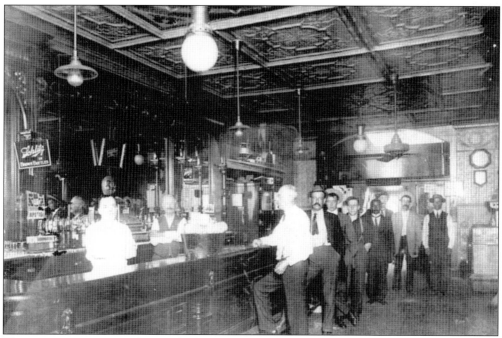

This is an interior view of a Nyack saloon.

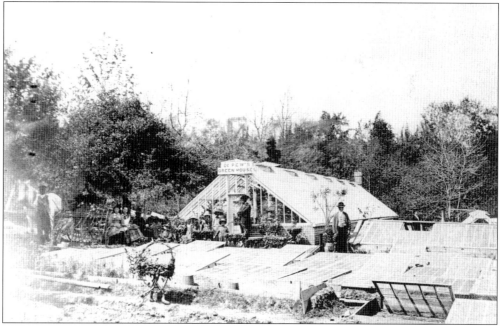

One of the many businesses in Nyack in the late 1800s was that of DePew Greenhouses, located at Piermont Avenue between DePew and Hudson Avenues, where Memorial Park is now located. Numerous employees tended the flowers, especially roses, grown for the New York City market.

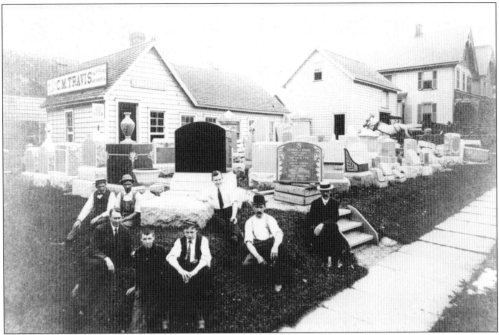

Under the present stucco of Travis Monuments, at Main Street and Midland Avenue, is one of the oldest houses in Nyack. This picture shows that original structure; inside, its wide floorboards and fireplaces remain. The company was founded in 1898 by Clarence W. Travis, seen in this photograph sitting on the left.

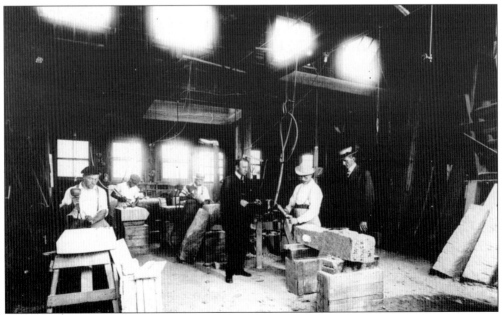

This photograph of the interior of the Travis shop shows Travis and some of the employees. Travis advertised "fine monument and cemetery work" and offered everything from mausoleums to corner posts. He died in Nyack at the age of 89; his sons continued the business.

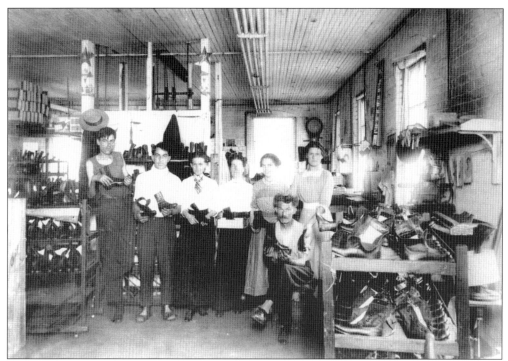

The King shoe factory is pictured here around 1900.

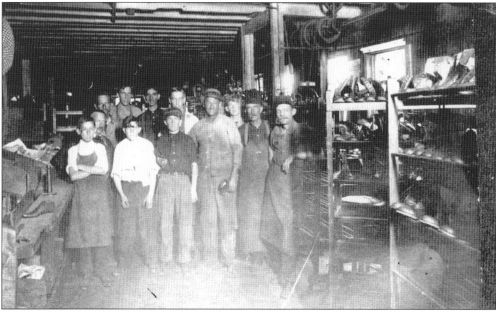

Nyack had a lively shoe industry dating back to the 1820s. Originally, the shoes were made by hand, but by the 1860s, machines had been introduced. The products of the employees' work are visible here. Note the shoemaking tools on the left.

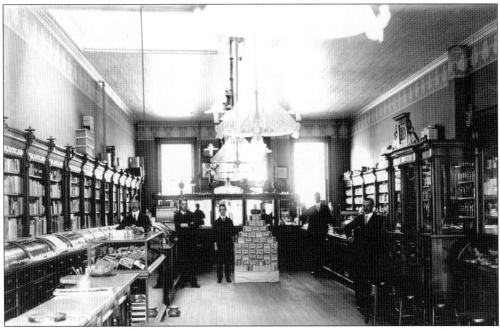

This is the interior of the John D. Blauvelt drugstore, at 96 Main Street, later Whelan's and now Koblin's. John Blauvelt opened his store in 1890, claiming to establish "one of the finest and most exclusive drug stores in the lower Hudson Valley." Prescriptions were "carefully and promptly" filled behind the counters on the right. The soda fountain is visible on the left.

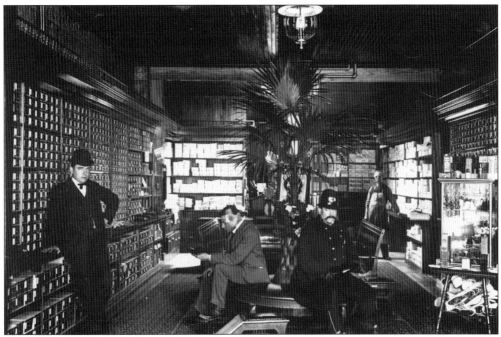

Glynn's Shoe Store, located at 136 Main Street, was founded in the 1890s and remained in the Glynn family for three generations. In this photograph, police chief Thomas Curran is pictured in the foreground.

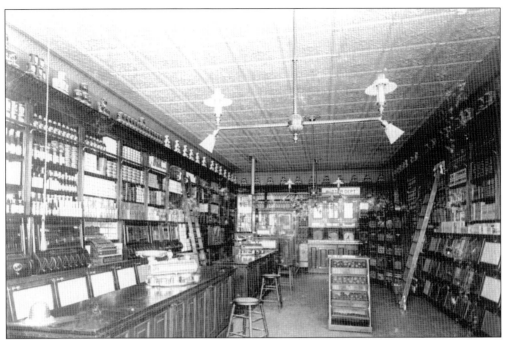

Pictured here is Geynore's Grocery.

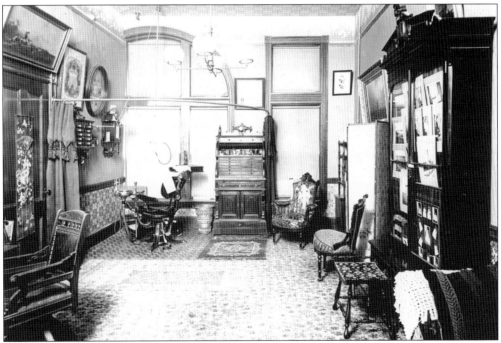

The dental offices of Dr. John T. Gilchrest and his father, Dr. Harvey Gilchrest, were located at 96 Main Street above the John Blauvelt drugstore. The room was decorated in the Victorian style of the times. Note the dental chair in the background.

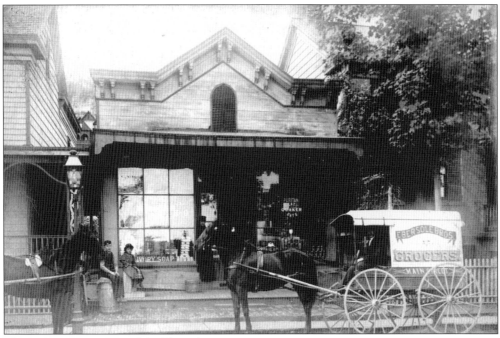

This is an exterior view of the Ebersole grocery.

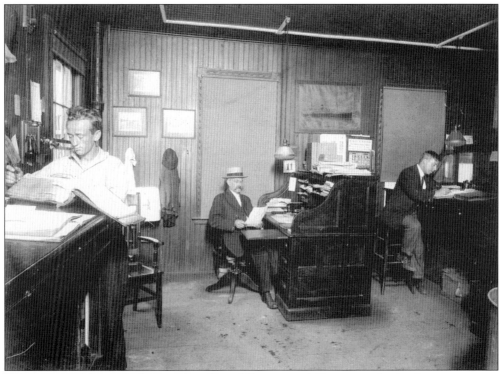

Three men are shown working in the office of Gregory and Sherman, a lumber business.

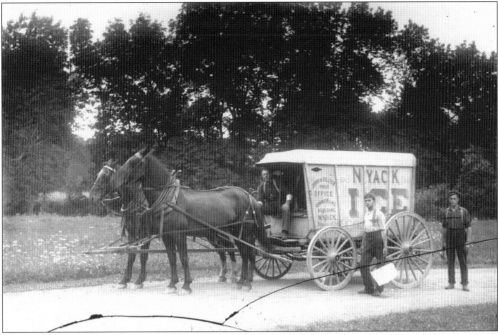

The Nyack Ice Company truck is pictured in the early 20th century. It was owned by John N. Felter until 1921, when it was purchased by Gilbert Crawford.

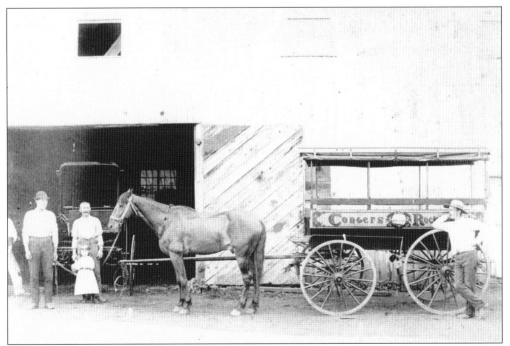

A livery stable was at the corner of Church Street and Liberty Street at the rear of the Tappan Zee Playhouse site. It was badly damaged in a fire that destroyed its horses. Note the Congers-Rockland Lake stage at right.

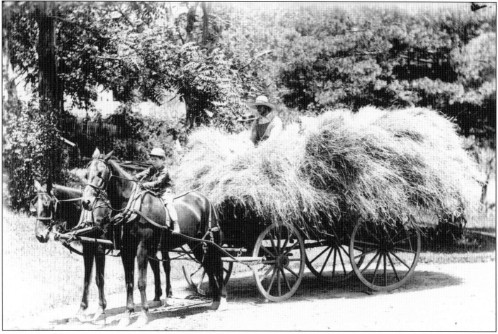

A load of hay was a common sight in the village until around the 1920s. Every family of importance had its own horse, and there were many livery stables.

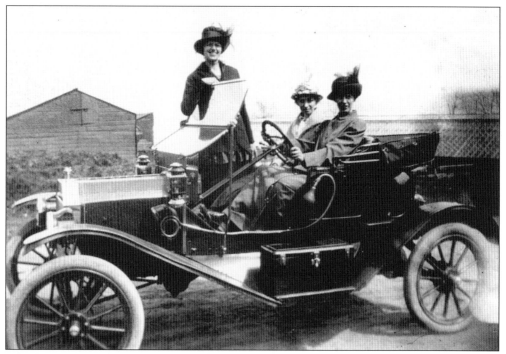

Julie Sauter, Mrs. Goddard (Havlik), and Elizabeth Cypher pose with the Goddards' car on Route 9W in Upper Nyack.

In this 1907 photograph, taken on Summit Street in South Nyack, are Frank Axel Ofeldt, wife Johanna, and their daughters Lotta and Jennie, with neighbor Wesley Jackson. A South Nyack resident, Ofeldt brought the Ofeldt steam car to the village. It was capable of speeds of 10 miles an hour. He and his brother had a factory on Main Street, where they built steam boilers and launches. He manufactured his horseless carriages in Brooklyn and later in Nyack.

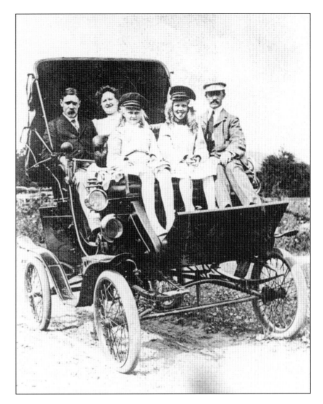

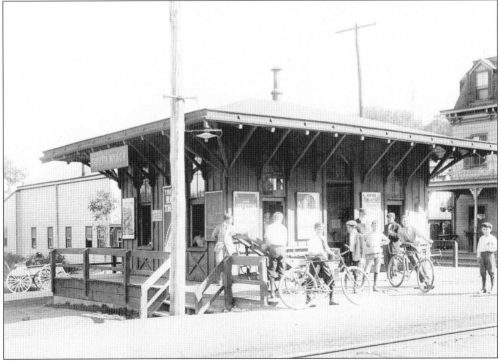

Boys gather at the South Nyack railroad station.

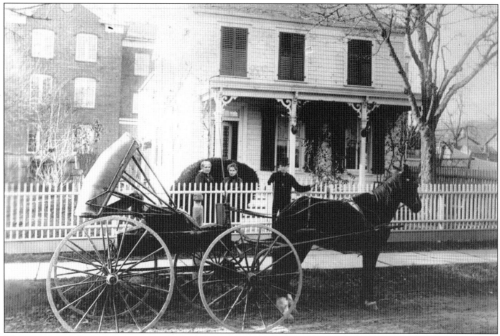

This image, labeled "Horse and Buggy in front of houses," was printed in 1915 from an older photograph. Liberty Street School is in the background.

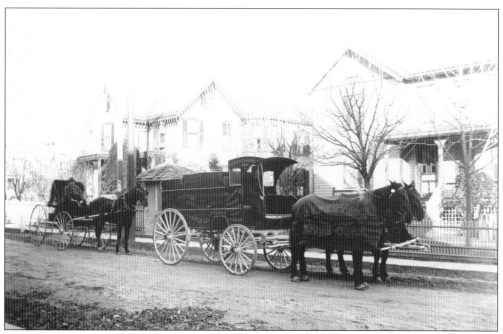

"Medicine Man" Everett Carpenter's "pharmacy wagon" is seen here. The blankets on the horses advertise his cough cure.

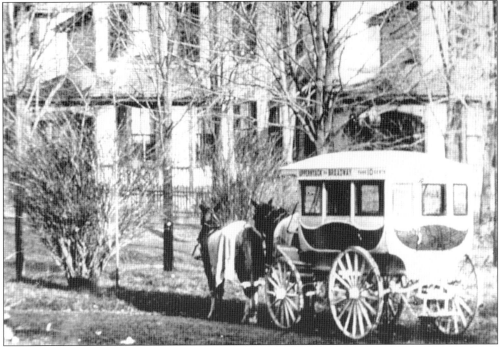

A stagecoach waits at South Nyack railroad station to take Upper Nyack commuters home around 1900. The trip would be made up Broadway for a fare of 10¢.

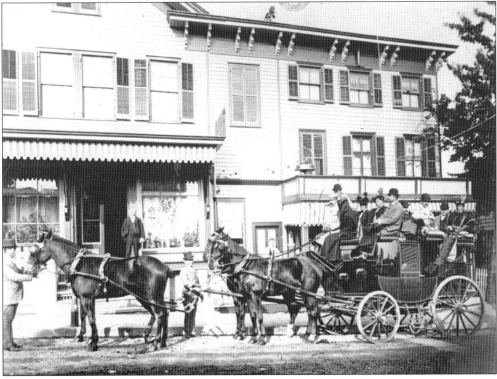

A stagecoach stops at the St. George Hotel.

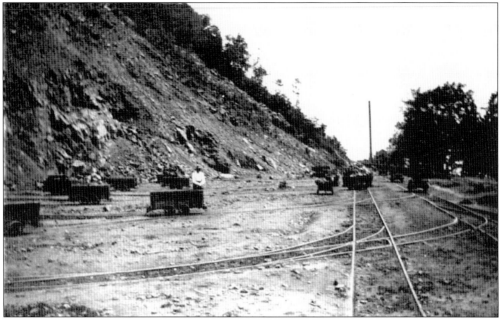

A worker stands next to a cart at Hook Mountain Trap Rock Quarry in 1909. In the background, a cart on the track is loaded with stone.

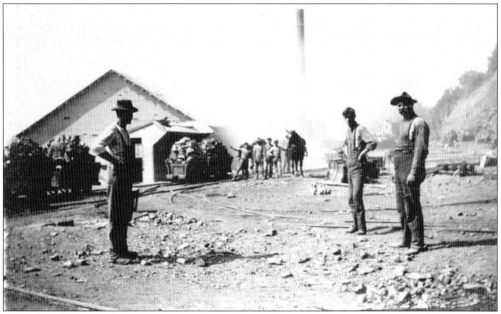

An extensive network of railroad tracks and gondolas was used to haul rock from the quarry area to the rock crusher and then to the waiting ships and barges. Workers can be seen in the foreground of this early-20th-century photograph, while the smokestack of the steam power plant is visible by the river.

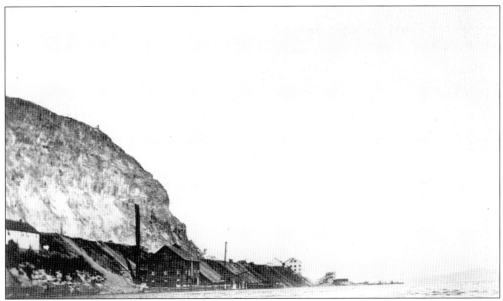

This photograph from the early 1900s shows one of the stone crushers and piers that were located around Hook Mountain. Note the two tunnels leading into the mountain. Two similar tunnels may still be seen at the north end of the bathhouse at Nyack Beach State Park.

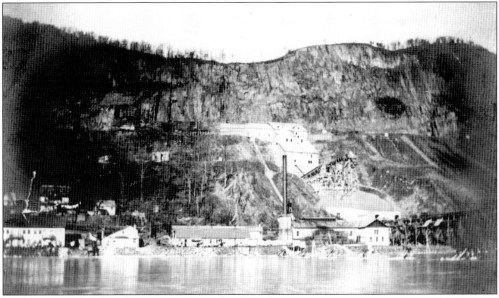

Rockland's rocks created the first major industry in the Nyacks. Nyack farmers quarried the stone they found on their farms to build their homes and then commercially exploited this abundant natural resource. In the early 19th century, 31 quarries were operating along the riverfront from Grand View to Hook Mountain, employing hundreds of well-paid workers for this hazardous occupation. Rock from Nyack's quarries was used in the construction of New York's state capitol building at Albany, Rutgers University in New Brunswick, New Jersey, and many buildings in New York City. In 1898, the Nyack village board joined the fight to prevent the sale of the quarry to the largest stone-crushing company in the United States. The quarry was acquired by the Palisades Interstate Park Commission in 1901.

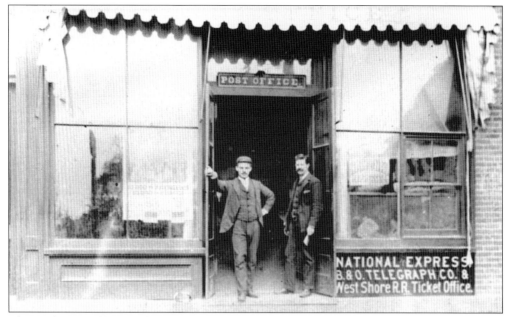

This early post office was located in the Doersch Building on the northeast side of Broadway and Remsen Street. In 1892, the federal government procured a site from the DePew family with intentions to build, but it was the Rotary Club in the 1930s that finally pressured the government to use the land. The Rotary Club gathered 2,000 signatures on their petition, and in 1933, the present post office was built.

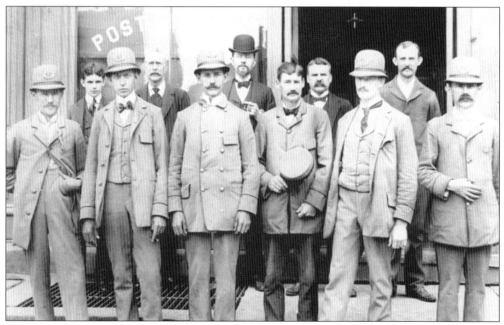

Six uniformed postal workers stand in front of five employees in business suits in 1890. "Post Office" is printed on the window.

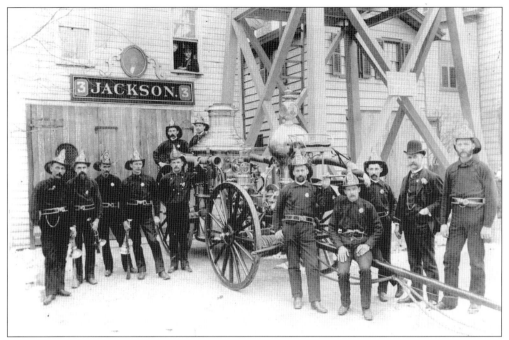

Members of the Jackson Engine Company pose in uniform and helmets with their gleaming steamer in front of the engine house in 1885. The steamer is identified as a Clapp and Jones. The site was taken for urban renewal in 1960.

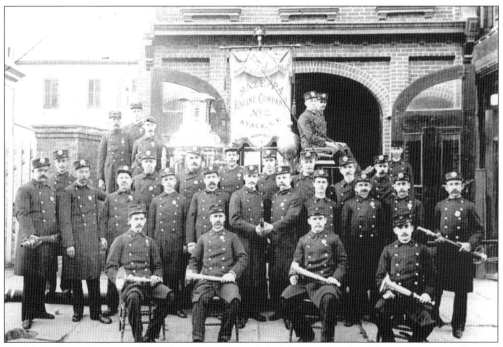

On Main Street just east of Broadway, members of the Mazeppa Engine Company pose in front of their building and steamer in 1890. The firehouse is still used and remains relatively unchanged.

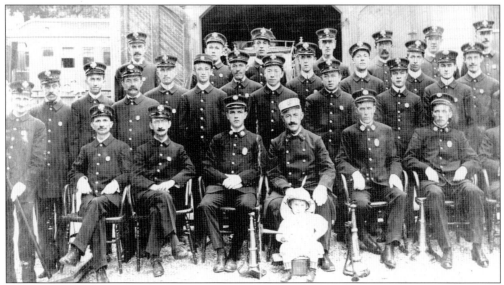

Orangetown Fire Company No. 1, the oldest in Rockland County, was established in 1834. This photograph dates from 1908.

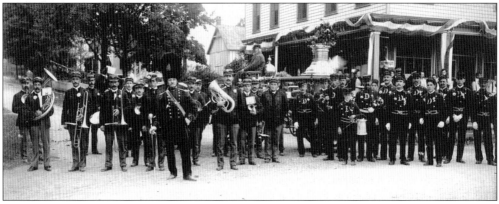

Defender Engine No. 1. is pictured in Upper Nyack in 1905.

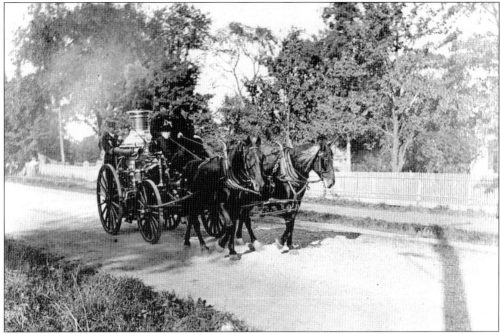

A small steamer carrying three firemen is pulled by two dark horses around 1885. In the 1880s, hand pumps gave way to steamers, which generated stronger and more efficient pressure for the release of water from hydrants and cisterns.

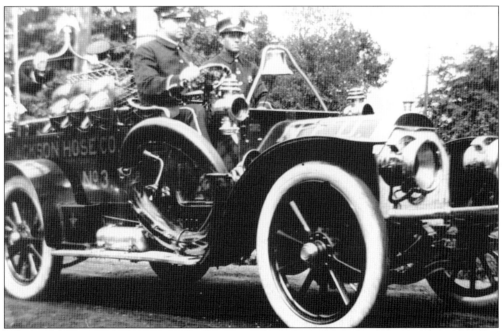

Nyack's first motorized hose wagon, property of the Jackson Hose Company, was a fire engine body transplanted onto a Stearns touring car. It arrived in the fall of 1911 just in time for the Firemen's Parade.

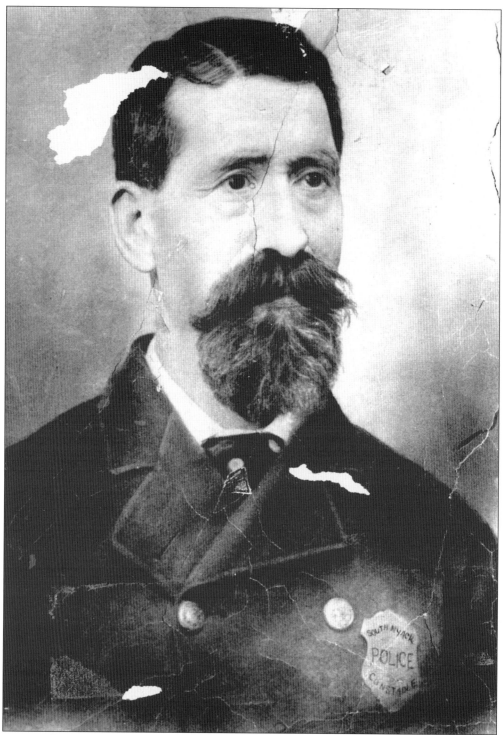

Michael Crowley, the first uniformed police officer in Rockland County, served as chief of police and street commissioner in South Nyack. He died in 1918.

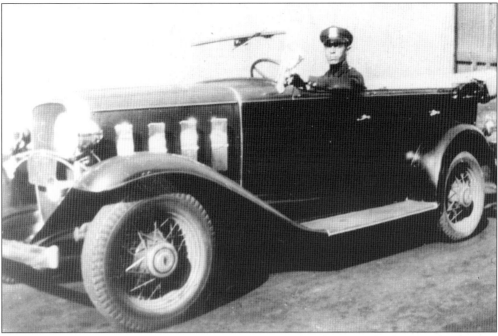

Officer Raymond Strack sits at the wheel of an early Nyack police car. The first Nyack police car was a Whippet, purchased in the 1920s at a cost of $550. The village board debated whether to buy a car or a motorcycle.

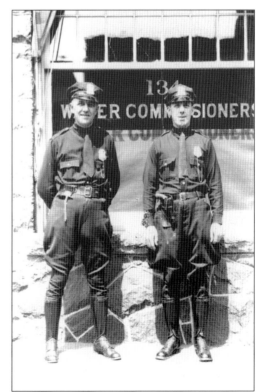

Two policemen pose for a picture. Joseph O'Connor is on the left.

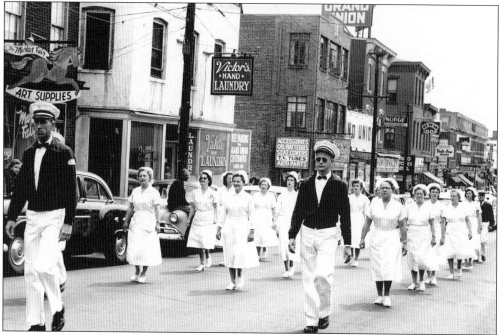

Members of the Nyack Community Ambulance Corps march up Main Street in a 1955 parade. A number of businesses on the north side are visible, including Market Fair, Victor's Hand Laundry, the Grand Union, and Hawvermale Hardware.

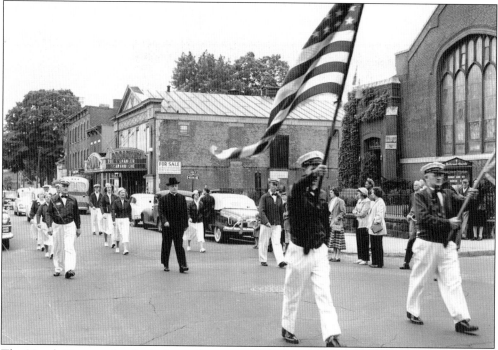

The Nyack Community Ambulance Corps marches past the Broadway Theatre (Tappan Zee Playhouse) and the First Reformed Church in 1948. Founded in 1939, the corps has provided ambulance services for the Nyacks for over 60 years.

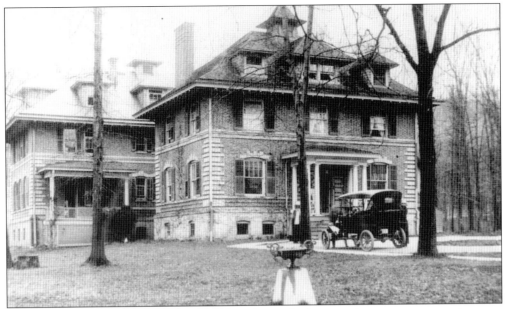

Nyack Hospital opened on January 1, 1900, with nine beds, one private room, a reception area, operating room, nurses' parlor, and dining room. Additions and alterations were made over the years so that upon its 100th anniversary in 2000, it had 9 operating rooms, 375 acute care beds, 27 bassinets, and more than 350 employees. This picture dates from 1900. Nyack Hospital grew from an idea of Stephen R. Bradley. Dr. George Leitner was chief surgeon until his death in 1931, and many of Nyack's professionals served on the board, including DuPratt White.

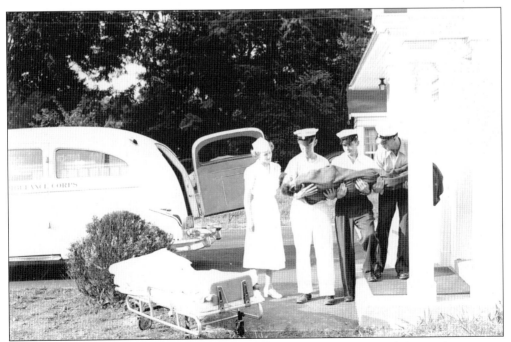

Members of the Nyack Community Ambulance Corps participate in a training session.

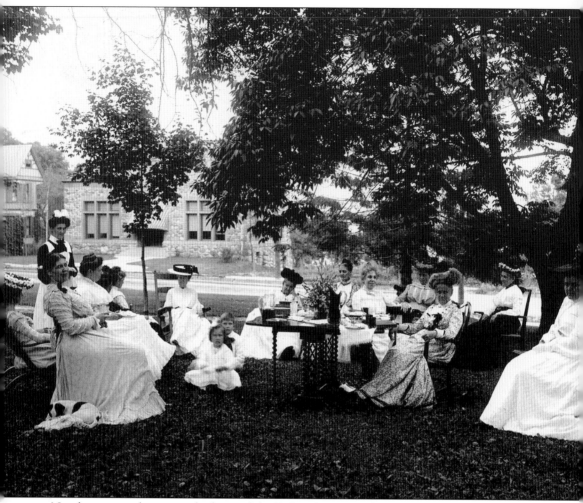

Nyack women take tea on the lawn of the DePew House in the summer of 1905. Their dresses are trimmed with lace, and several wear elaborate hats. A maid stands on the left, and two children sit on the ground. The new library is in the background.

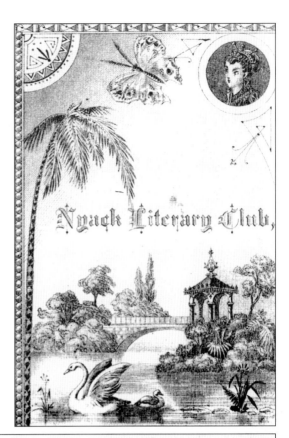

This Nyack Literary Club program dates from 1880.

THE

DOCTOR OF ALCANTARA,

AN OPERA,

IN TWO ACTS,

GIVEN BY MEMBERS OF THE

Nyack Literary Club,

AT THE

NYACK OPERA HOUSE,

Monday Evening, February 9th, 1880,

AT EIGHT O'CLOCK.

DRAMATIS PERSONÆ.

DOCT. PARACELSUS, - - -	MR. J. B SIMONSON.
SENOR BALTHAZAR, - - -	MR. J. H TINGLEY.
CARLOS, His Son, - - -	MR. G. D. WILSON.
PEREZ } Porters, - - -	MR W. M'CORKLE.
SANCHO, } - - -	MR. C. M'CORKLE.
DON POMPOSO, - - -	MR. J. T. HARTFORDE.
DONNA LUCREZIA, } wife to Dr. Paracelsus, }	MISS F. A. LATHROP.
ISABELLA, Her Daughter, - -	MRS. G. D. WILSON.
INEZ, Her Maid, - - -	MRS. E. H. MAYNARD.

CHORUS.

ACCOMPANIST, - - -	MISS EVA BLAUVELT.

SCENE:

ALCANTARA, IN THE HOUSE OF DOCTOR PARACELSUS.

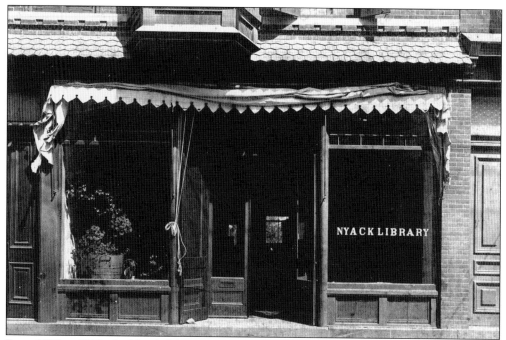

From 1885 to 1903, the Nyack Library was located in a store at 79 South Broadway. When the trustees decided to move the library, they wanted a place "where there could be light and sunshine and a free reading room as an added inducement." The store is now a dry cleaning business.

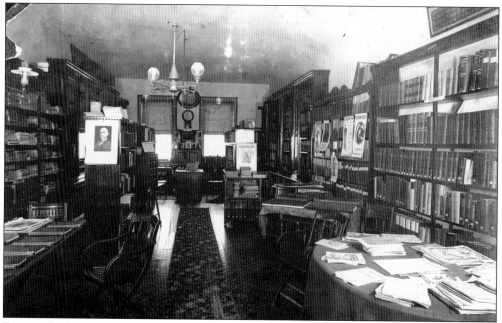

Emma Thorburn was librarian earning $15.50 a month when the library moved to the South Broadway store in 1885. While here, the library became a free library, supported by taxes. There were 3,000 volumes in the collection by 1893, and *David Copperfield* was the most popular novel.

Near the intersection of Hudson Avenue and Broadway in 1899, a barn occupies the future site of the Nyack Library. The Wright Insurance Building is just visible on the far left.

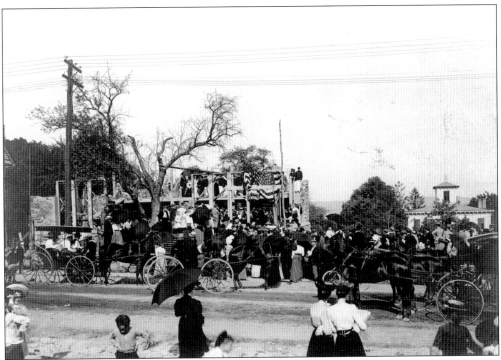

The entire community turned out for the May 21, 1903, laying of the cornerstone of the Nyack Library. Andrew Carnegie had contributed $15,000 for the building's construction. Some sat in wagons, some on the lawn or street, and others inside the unfinished structure.

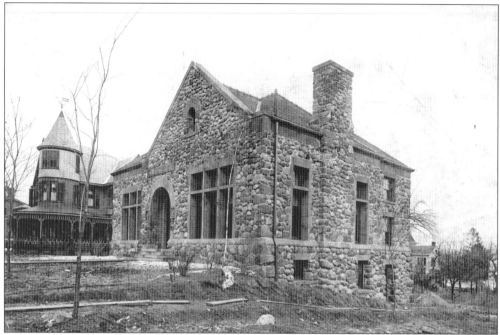

In 1904, the new Nyack Library stood on the south side of Broadway. Trees had not yet been planted, and ivy had not yet covered it. Its river-stone construction was unique in the village of Nyack.

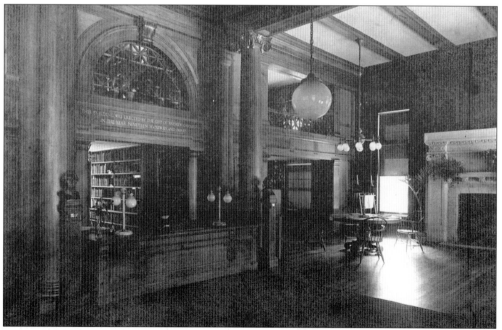

In 1904, the oak woodwork and flooring of the Carnegie Room of the Nyack Library were gleaming. The circulation desk faced the main entrance, and books were on shelves behind it. The inscription reads, "This building was erected by the gift of Andrew Carnegie in the year nineteen hundred and three."

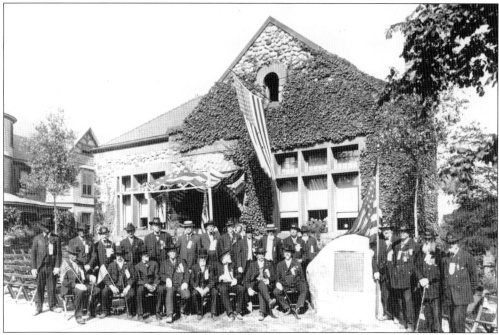

On June 13, 1908, the Lincoln Memorial Boulder was unveiled in front of the Nyack Library. The children of Nyack raised the money for the plaque, on which the Gettysburg Address is printed. Around the boulder are two dozen elderly men, many wearing Civil War hats. All were members of the Waldron Post, Grand Army of the Republic, and had wanted a remembrance for their comrades.

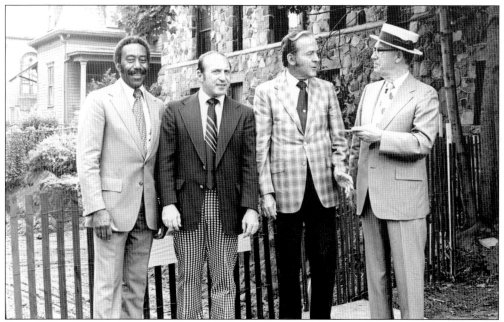

County legislator Hezekiah Easter, state assemblyman Gene Levy, state senator Donald Ackerson, and library president Kenneth MacCalman attend the 1973 groundbreaking ceremony for a large addition to the library.

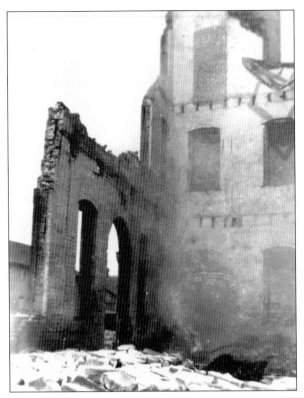

The Aniline Dye Company building on Hudson Avenue had long been seen as a fire hazard, and the fire department had prepared advance plans for fighting a fire there. The fire, with explosions, came on January 31, 1919, and was one of Nyack's worst, killing 2 and injuring 13. Windows were broken in many other structures in surrounding blocks. The Liberty Street School, with 1,200 students in attendance, was directly across Hudson Avenue from Aniline; it was quickly emptied. After the fire, Nyack increased its fire restrictions, which drove the Aniline Dye Company to close its operations here.

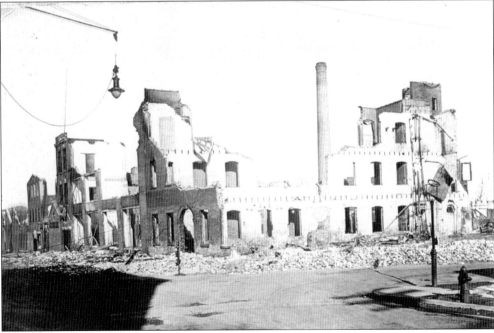

Pedestrians pass by the fire at the Aniline Dye Company in 1919 while the upper story of the factory is ablaze. A fire truck is in the street, and a few firemen can be seen near the building.

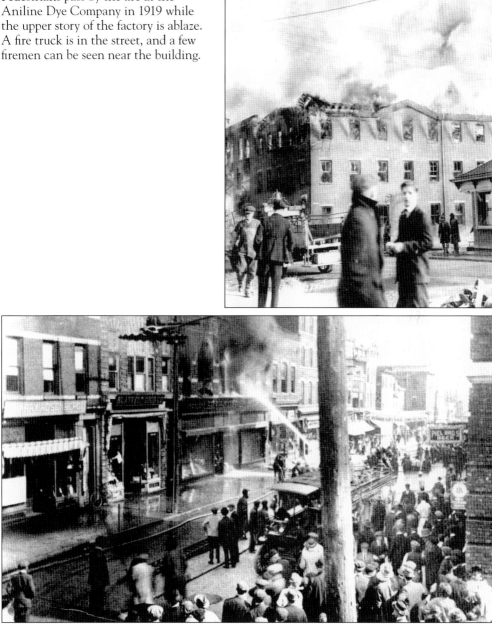

The building at 92 Main Street was the site of a terrible fire. On the afternoon of October 13, 1915, a fire started in the cellar of one of Nyack's premier businesses, the Harrison and Dalley department store. It spread quickly, aided by a mighty wind. All of the fire companies of the Nyacks responded, as did those of Piermont, Pearl River, Spring Valley, Suffern, Congers, and Haverstraw. The heat was so intense that it blistered the paint on fire trucks and overcame 12 volunteer firemen with its smoke. The two-ton safe, located in the second floor offices of the store, came crashing through to the basement, and the structure itself was gutted. One of the owners, John W. Harrison, was a volunteer fireman for the Mazeppa Fire Engine Company No. 2 and would have been fighting the blaze if he had not been away on a business trip.

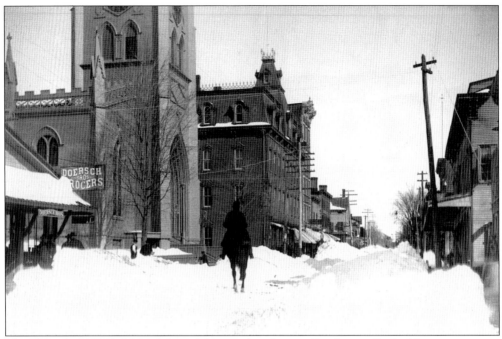

The Blizzard of 1888 left Nyack buried deep in the white stuff and was talked of for generations.

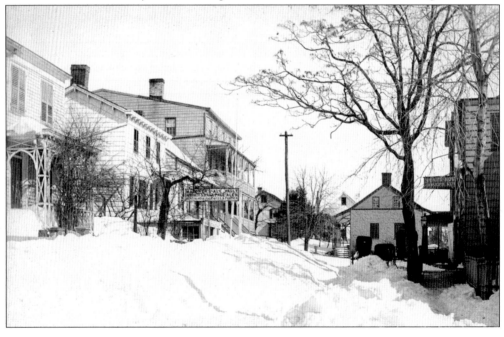

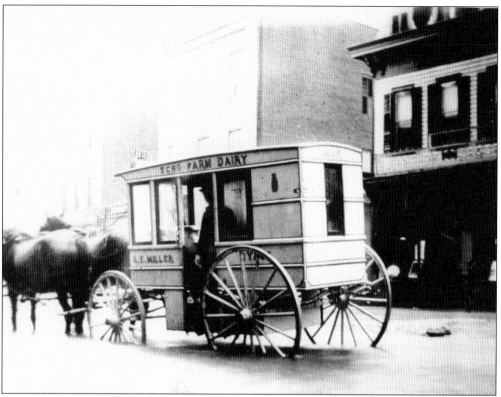

Nyack Brook was used in the 1800s to power village mills. Extreme weather conditions have occasionally caused major flooding. During the 1948 flood, longtime residents said that more water flowed down Main Street than at any other time within memory.

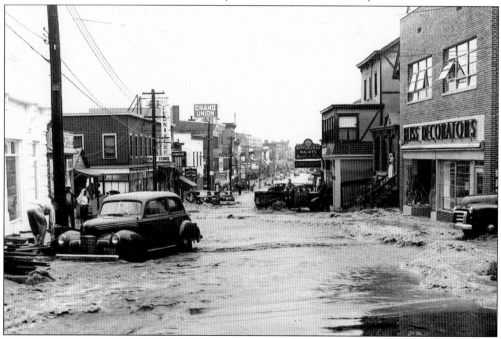

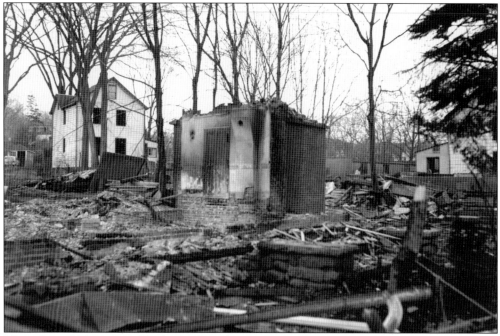

More than 100 homes in South Nyack and many magnificent trees, as well as the village hall, police station, and railroad station, were lost to make way for the New York State Thruway in the early 1950s.

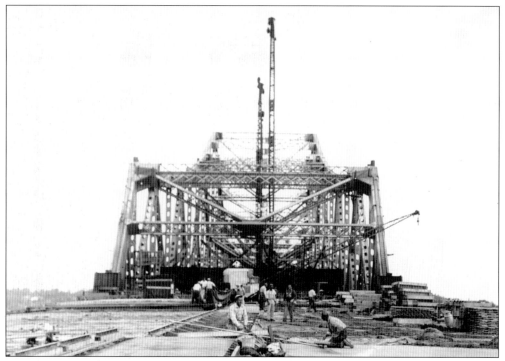

Construction of the Tappan Zee Bridge began in March 1952. Buoyant concrete tanks float in the mud at the bottom of the river to help support the weight of the bridge.

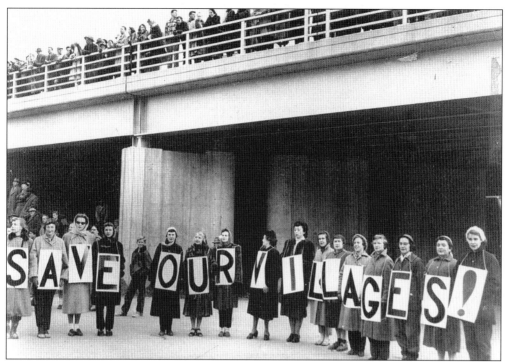

South Nyackers and their neighbors protested the building of the bridge with intense demonstrations and petitions to Albany.

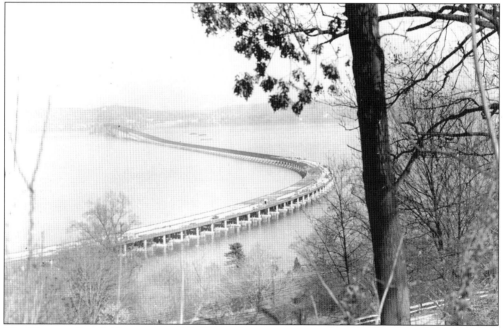

The Tappan Zee Bridge, a graceful, filigreed structure spanning the Hudson from Nyack to Tarrytown, connects the eastern section of the New York State Thruway north to Albany and west to Buffalo. On clear nights, the bridge has been likened to a sparkling necklace flung across black velvet.

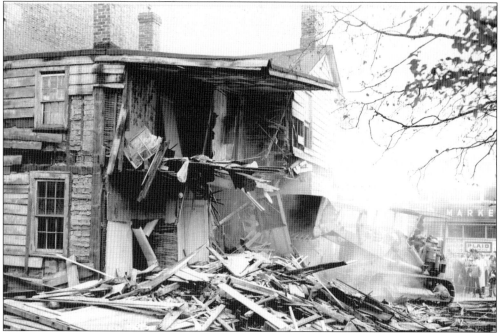

In the 1950s, when Nyack lost its footing as the retail hub of Rockland, the village board acquired urban renewal funds to upgrade the structure and appearance of the town center. A complex of business buildings and a frame house were demolished on the west side of South Broadway. Tallman Towers apartments went up in their place.

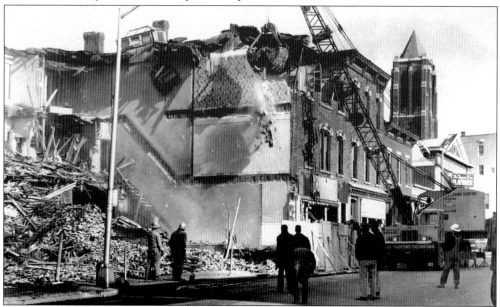

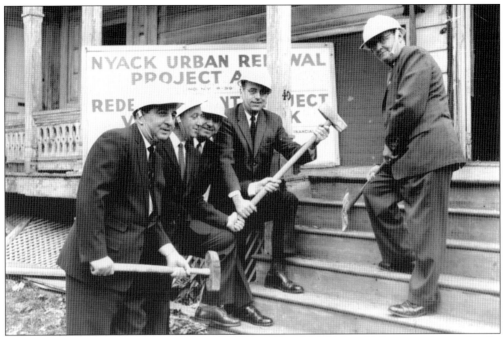

Urban renewal money took down a house on the corner of Franklin and Main to make way for the Tappan Zee Bank. Gene Setzer, known as "One Vote Setzer" due to his margin of victory in the village board election, cast the deciding vote in favor of the urban renewal application. Below, he stands, with fedora, to the right of a group of men around a barber's chair found in the house.

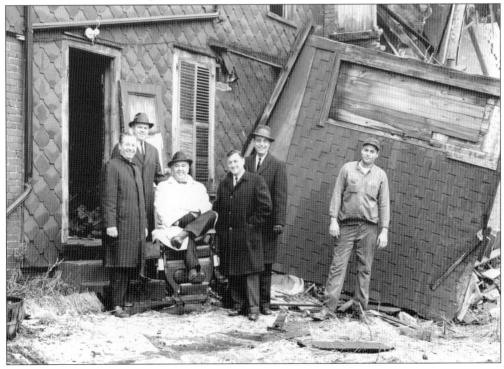

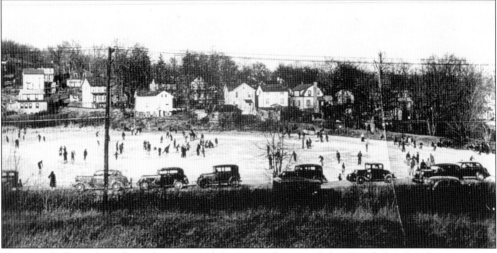

Skaters of all ages, singly and in pairs, slide across the ice of the Nyack Ice Pond on a wintry day around 1930. Located where the Best Western and interchange 11 of the New York State Thruway are now, the pond provided both industry and entertainment.

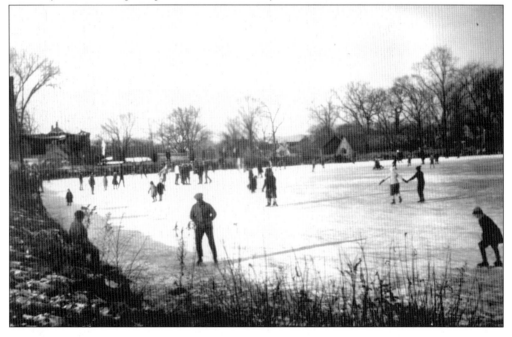

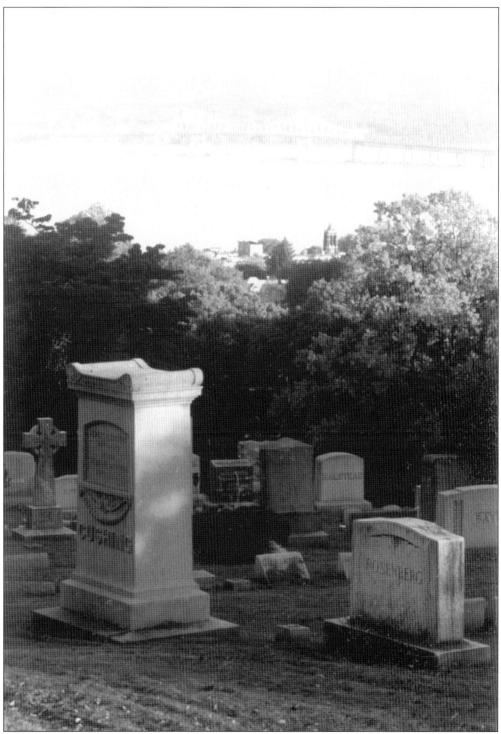

Oak Hill Cemetery headstones can be seen in the shadows in the foreground, and downtown Nyack can be seen in the middle ground. Beyond is the Hudson River, spanned by the Tappan Zee Bridge. This is a photograph by Fred Burrell.

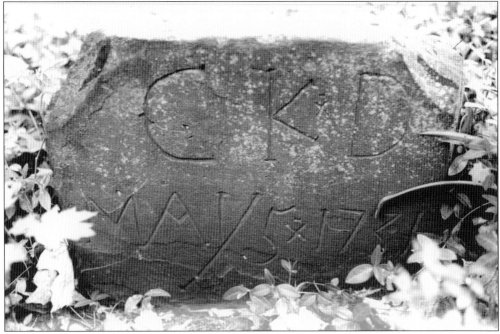

Pictured is a gravestone in Upper Nyack Cemetery. CKD stands for "Cornelius Kuyper died." He, his wife, and their children and slaves were the first settlers of Upper Nyack, arriving around 1687. He became a justice of the peace, a colonial legislator, and a colonel in the militia.

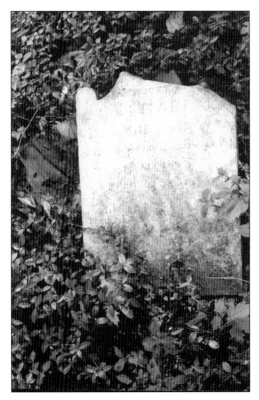

Catherine Palmer, who died in 1803 at the age of 24, was the wife of William Palmer, who helped found the Old Stone Church in 1813. William's brother James deeded the "old Palmer Burying Ground" to local residents in 1837. Catherine's gravestone reads, "Afflictions sore long time I bore / Physicians arts were vain / Till death did seize and God did please / To ease me of my pain."

Three

ARCHITECTURE

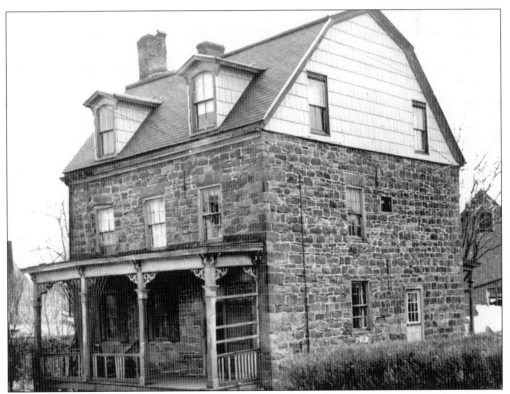

Perhaps the oldest extant residence in the village of Nyack is the John Green House, shown here in 1900. This sandstone house with a gambrel roof belonged to one of the Nyack community's founders, John Green, and was built about 1818. It stands on lower Main Street, where he had a lumberyard and general store as well as his own river landing. John Green was a cofounder of the Methodist congregation, a stockholder in the Nyack Turnpike, and a major shareholder in the Nyack Steamboat Association, which launched Nyack's first steamboat, the *Orange*, in 1827.

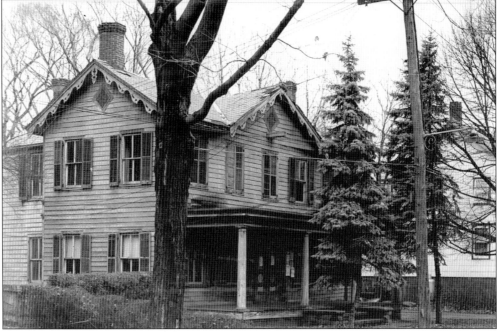

The former South Nyack Village Hall, shown in 1952, was in an old Queen Anne–style Victorian house. It was lost to New York State Thruway construction in the 1950s.

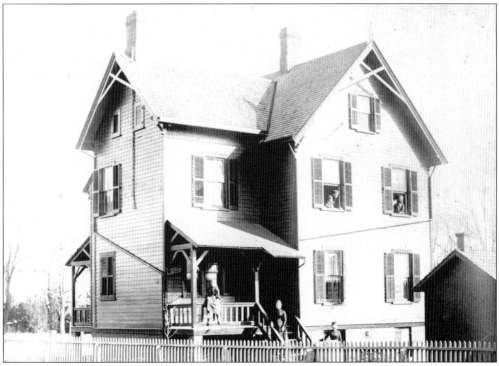

This house on Second Avenue was the residence of retired liquor merchant Benjamin Eckerson. It was part of a middle-class neighborhood of merchants and professional people along North Broadway and adjacent streets.

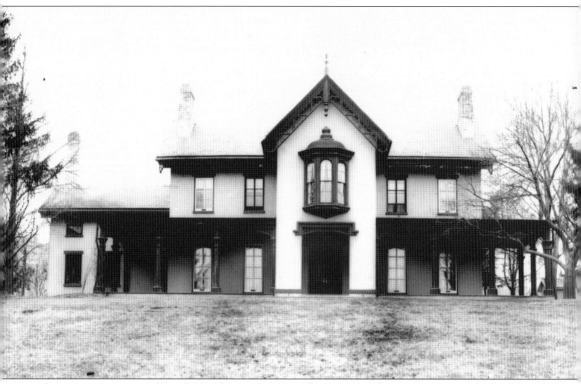

The most prominent of South Nyack's residences is the Ross-Hand Mansion, on South Franklin Street, built in 1859 by Azariah Ross, who was both architect and builder. The celebration of the Northern Railroad's arrival in Nyack was held in this house in 1870. In 1883, the Hand family acquired the property for $9,000, and it was later the residence of inventor William Hand. He had been an assistant to Thomas Edison, helping to create the plastic used in phonograph records and inventing a long-life battery used by the U.S. Navy and in emergency vehicles. Among his many gifts to the community were the Orangetown Fire Company site and building.

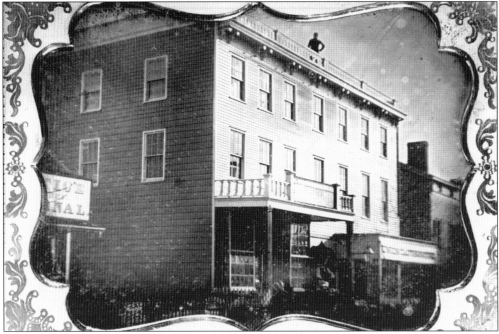

Union Hall, pictured in the 1850s, was built on Main Street in the early 1850s for lectures, concerts, and other amusements. During the Civil War, volunteers drilled here, and Union sympathizers held nightly meetings. It was the center of Civil War activities in Nyack.

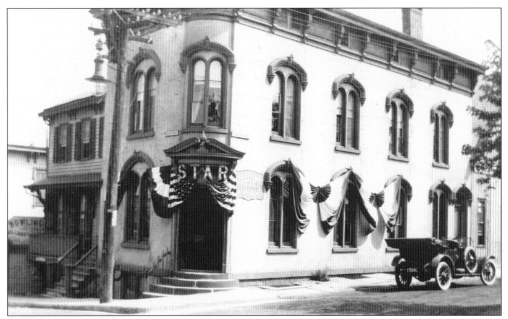

The *Evening Star* newspaper, published from 1892 to 1916, had its home in this building, located on the southeast corner of Piermont Avenue and extending to Spear Street. When it was first built, it served as a banking facility. The *Star* was the only daily newspaper in Rockland County and the only one west of the Hudson between Jersey City and Newburgh. A bowling alley was located in the basement.

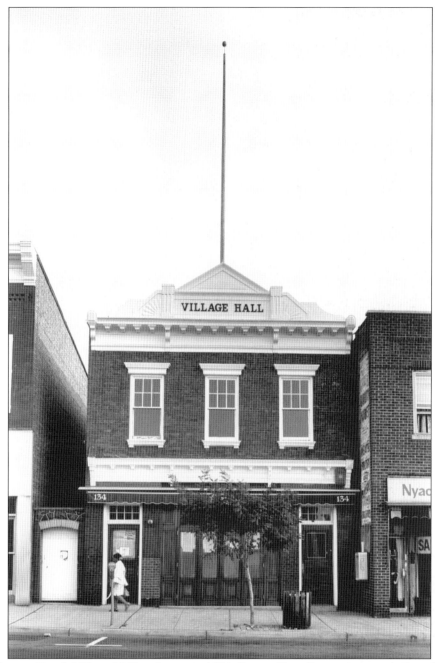

The former Nyack Village Hall is shown in 1984. Originally, village government shared these Main Street quarters with the Jackson Hose and Engine companies; the fire department was on the first floor, and the village government was on the second. Following a 1909 fire that gutted the building, the fire companies relocated to a new site. Village government remained on the second floor of the reconstructed building, while the police department took over the first floor and rebuilt to order, including a lock-up. In 1970, the Orange and Rockland building on North Broadway became the new village hall and police station. The Main Street building was sold and became the Hudson House Restaurant. The jail is used for wine storage.

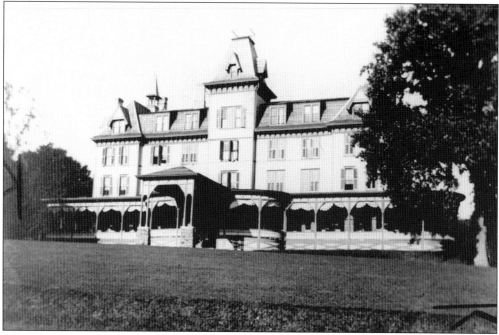

The Prospect House was located on South Boulevard at the corner of South Highland Avenue. Pictured around 1880, it was built as the Palmer House and operated under that name for three or four years. It was then bought by Thomas J. Porter, who renamed it and continued its fame as a residential hotel. Among its guests was Pres. Grover Cleveland. Some 225 people could be accommodated in the dining room, and it was noted for its fancy balls. Just before the summer season in 1898, it was completely destroyed by fire.

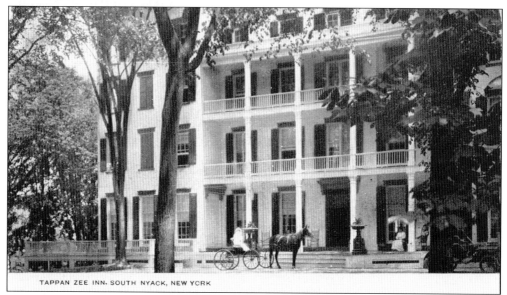

TAPPAN ZEE INN· SOUTH NYACK, NEW YORK

The Tappan Zee Inn was formerly the Rockland Female Institute and later the Hudson River Military Academy. Charles MacArthur and Ben Hecht rented the whole building to write the play *Front Page* in the 1920s.

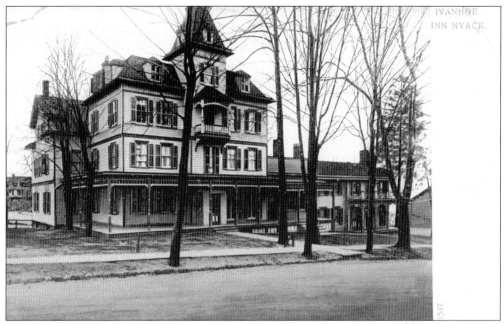

This view shows the Ivanhoe Hotel, site of the present Ivanhoe apartments.

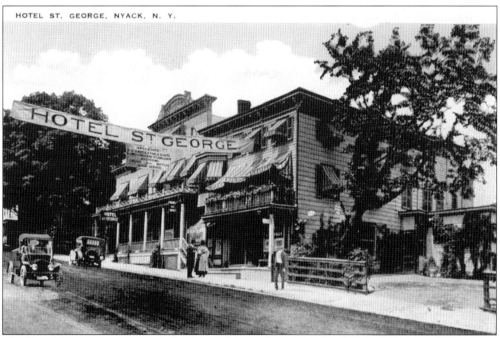

The Hotel St. George, pictured in 1910, is the best known of the old hotels because the building still stands on Burd Street east of Broadway. It is now used for offices. Started by George Bardin in 1886, the hotel and its restaurant became the first stop for many travelers from the boat landing on Burd Street to the interior of Rockland and beyond.

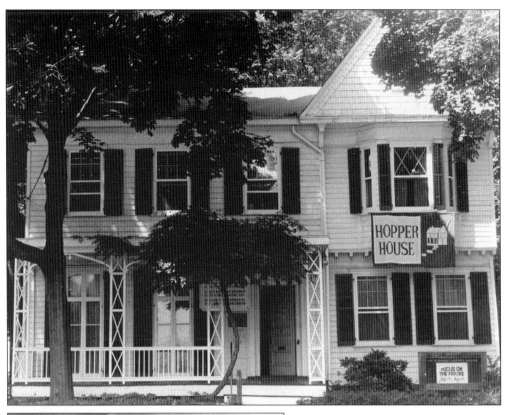

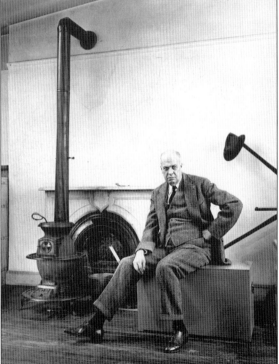

Edward Hopper, one of America's leading artists, was born in this North Broadway house in 1882. He was educated in Nyack's local schools and at the New York School of Art. He died in 1967 and is buried in Oak Hill Cemetery in Nyack. Rescued from demolition in 1970, Hopper House was restored and serves today as a local venue for the arts. The Edward Hopper homestead is listed on the National Register of Historic Places.

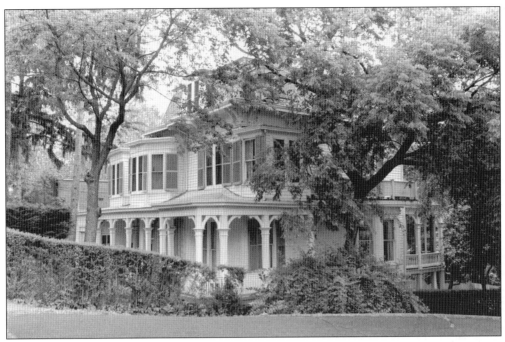

Georgia-born Carson McCullers spent more of her life here in South Nyack than in any other place. It was here that most of McCullers's best-known works were written. Tennessee Williams assisted her in converting her residence into apartments to help provide her with financial security. She entertained such visitors as Arthur Miller, Marilyn Monroe, Isak Dinesen, and John Houston here. Despite health problems that crippled her physically, she wrote until her death in 1967. With regard to her Nyack home, the *New York Times* quoted McCullers as saying, "I was always homesick for a place I had never seen, and now I have found it. It is here, this house, this town."

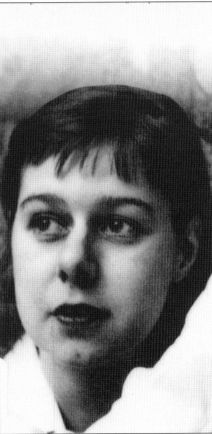

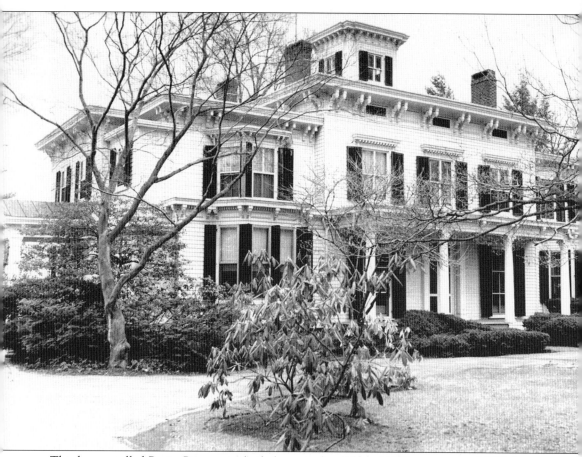

This house, called Pretty Penny, was built for retired merchant Eli Gurnee around 1857. It was best known as the residence of the first lady of the American theater, Helen Hayes, and her husband, playwright Charles MacArthur. A friend thought the MacArthurs had paid a pretty penny for the house in 1931, and the name caught on. Luminaries from the world of film, theater, and the arts visited the house frequently during the MacArthurs' residency. The house was memorialized in a painting by Edward Hopper. After her daughter and husband died, Helen Hayes continued to live here in her retirement, receiving old friends and new until her passing in 1993. In 1996, the house was restored by entertainer Rosie O'Donnell.

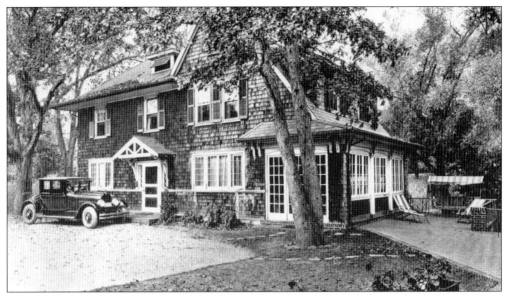

The Voorhis-Traphagen House is a massive 20-room Arts and Crafts–style house designed and built for Augustus Marvin Voorhis in 1910. The foundation and first-floor walls were made of local fieldstone and the second-story walls of brown shingle. Designed by the Emery Brothers, it has an unusual green ceramic roof. Voorhis had a real estate and insurance business and also served as president of the Nyack National Bank, president of the Nyack Gas Company, and member of the board of managers of the Nyack Hospital.

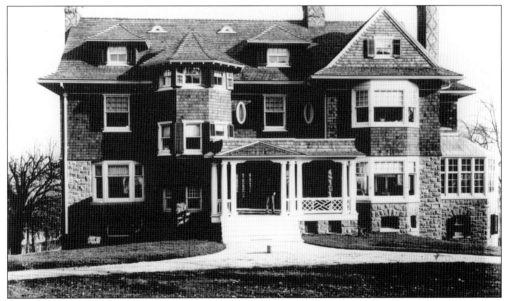

The Van Buren House was built in 1899 for attorney Howard Van Buren, a distant cousin of President Van Buren. The first story of this Shingle-style house has rusticated red sandstone walls, and the second story is of brown shingle. Designed by the Emery Brothers architectural firm, it was acclaimed in Hamlin's *History of Architecture* as a home for the new century. The occupant of the house also served as president of both the Village of South Nyack and the Nyack Library Board of Trustees.

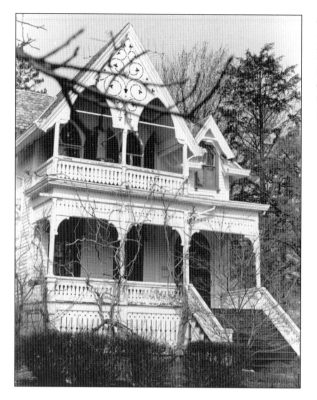

The house at 38 Glen Byron is an 1872 Gothic Revival delight. It has hood moldings over the windows, an elaborate rosette slate roof, and copious use of carpenter's lace—typical of many Victorian homes in Nyack.

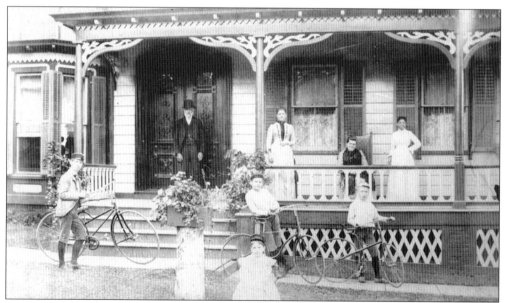

The William Tenbroeck Storms family stands in front of their house at 15 Tallman Avenue in the 1880s. Storms, a lawyer interested in politics, was an unsuccessful Republican candidate for Rockland district attorney and the next year was also defeated as his party's candidate for the assembly. In 1871, he was active in the movement to incorporate Nyack and was its first village clerk.

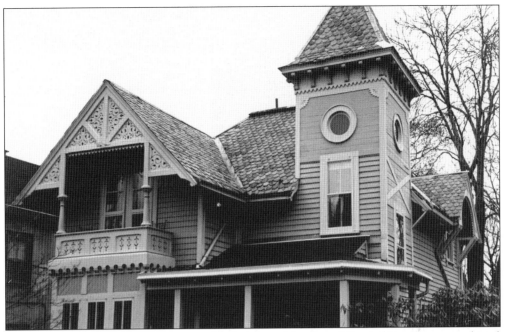

The house at 59 Jefferson Avenue is a delightful combination of Second Empire mansard roof, Carpenter Gothic trim, Italianate tower, and carved woodwork in gables and brackets under the bay window. This is an example of a builder house, for which a client could pick all the detail he wanted from a book.

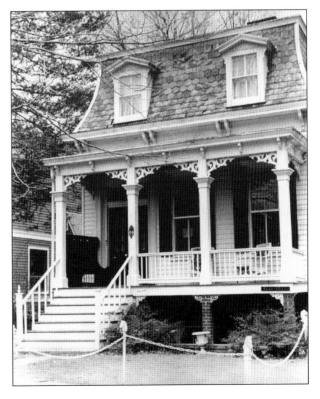

The house at 20 Sixth Avenue is a typical miniature Second Empire mansard style (c. 1873) to which additions were made in the early 1900s. Note the handsome porch pillars and etched-glass door.

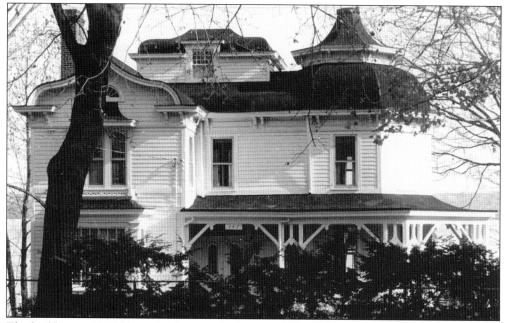

The building at 147 Piermont Avenue is a prime example of 19th-century eclecticism, possibly influenced by the octagon mode of Victorian construction. This was the yachting headquarters of Commo. William Voorhis, designer, owner, and racer of sailing ships and steamers, whose home was farther up the hillside. Of particular interest is the sectional composition of the house and the roofed portico, supported by pillars and forming half an octagon.

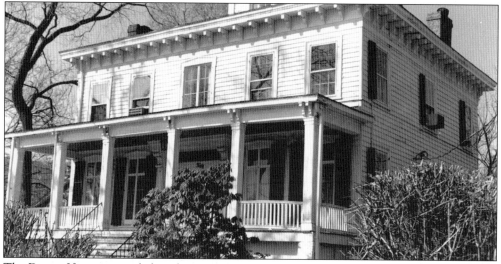

The Depew House, a simple but elegant Italianate farmhouse at 50 Piermont Avenue, was built in 1854 for Tunis Depew. He inherited his father Peter's vast Nyack estate and developed it, opening streets and constructing houses and factories. The largest property owner in Nyack, he declined an opportunity to become Nyack's first mayor. He built the Depew Place commercial block on South Broadway in the 1880s and grew flowers for the New York City market. His specialty was roses, and he erected greenhouses capable of housing 18,000 rose bushes on the site of the present Memorial Park. Depew also served as an officer of the Nyack Fire Department and as president of the board of education.

Nyack's first brick commercial building, at 1 Piermont Avenue, was built by Azariah Ross in 1839. Ross's general store was the first of a wide variety of retail stores operating at street level. The upstairs was generally occupied by a manufacturer, including one of Nyack's many 19th-century shoe factories. A hoist was installed about 1880, probably during the tenancy of a furniture storage and moving company. In 1924, Seeley and Company began to manufacture their flavoring extracts here, so that during the remaining years of the 20th century, the building was known locally as the "Vanilla Factory."

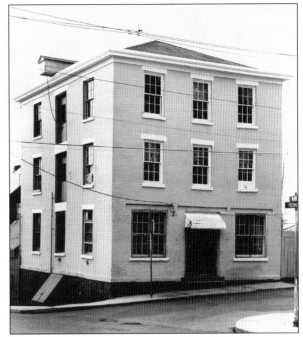

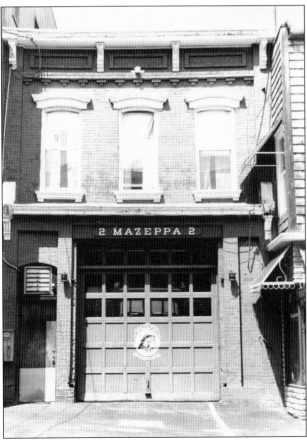

The Mazeppa Engine Company was Nyack's second fire company, established in 1852 and named after Lord Byron's heroic horseman. Note the hooded windows and elaborate brickwork.

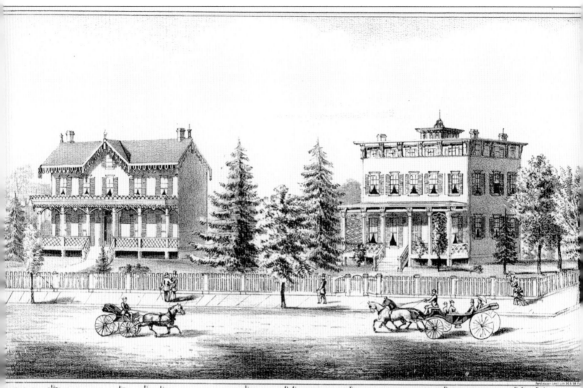

RES. OF D. J. BLAUVELT ESQ. NYACK, ROCKLAND COUNTY, N. Y.

This lithograph shows the residence of D. J. Blauvelt of Nyack (right), facing Broadway on the southwest corner of First Avenue. The building was the first home of the Rockland Center for the Arts.

Four

SCHOOLS

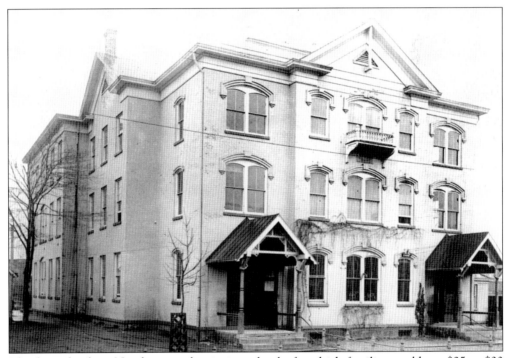

The first schools in Nyack were subscription schools, for which families would pay $25 or $30 a semester for each child enrolled. The small or one-room buildings were made of rough-hewn timber, as was the furniture. The first such school in Nyack opened in 1797 on Main Street, and Upper Nyack had its own school by 1845. Shortly after the beginning of the 19th century, Nyack's school was relocated to Broadway and Depew Avenue. A second story of the school provided space for public assembly and church services. After it burned down in 1827, a new school was built a little to the west on Liberty Street. Shown is the Liberty Street School, with the north side facing DePew Avenue, in 1903. The original building was constructed in 1852, with many later additions. It served both as a grade school and as Nyack High School until 1928, when it became an elementary school.

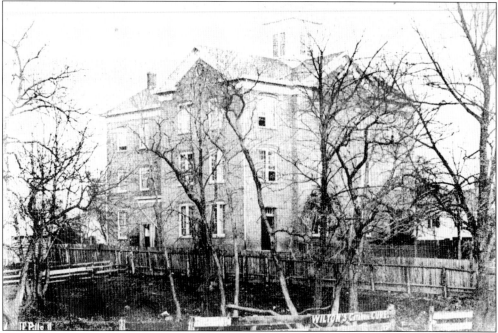

The earliest known photograph of the Liberty Street School shows how the building looked after its first remodeling and addition. Note the advertisements on the fence and on neighboring properties.

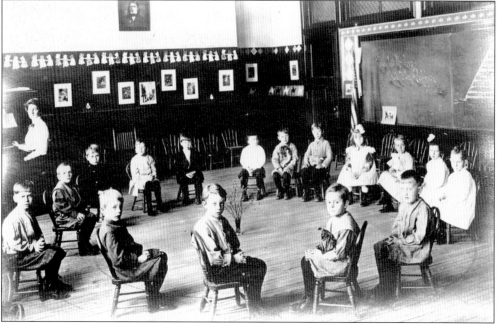

The kindergarten class of 1915 is pictured here.

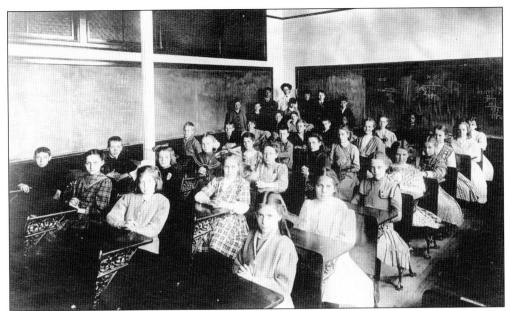

This is the fifth-grade class of Susan C. Blauvelt, who stands in a corner at the back of the room. Some students stand with the teacher, but most are seated at their desks. The blackboards contain long-division exercises. According to Gail Levin's biography of the artist, Edward Hopper is the boy on the left in the second row.

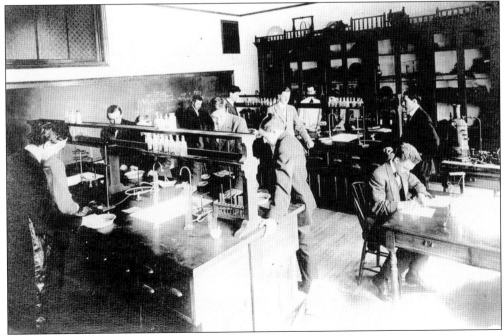

A chemistry class at Liberty Street School is pictured here in 1900.

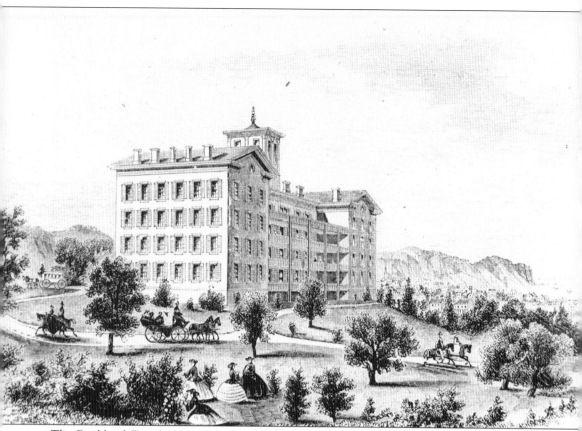

The Rockland Female Institute was erected in 1856, but from 1859 to 1870, it served as the Hudson River Military Academy. In the summers, it was used as the Tappan Zee Resort or Inn. W. H. Bannister reopened the building in 1876 under the name of Rockland College, which enrolled both men and women. In the early 1920s, it became the Nyack Club, and in the mid-1920s, it housed the Tappan Theater Group. Charles MacArthur and Ben Hecht rented the entire building while writing *Front Page*. Located in South Nyack on Mansfield Avenue, the building succumbed to fire in 1932 and was razed.

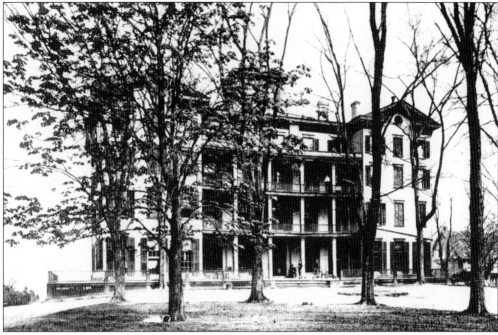

This is another view of the Rockland Female Institute.

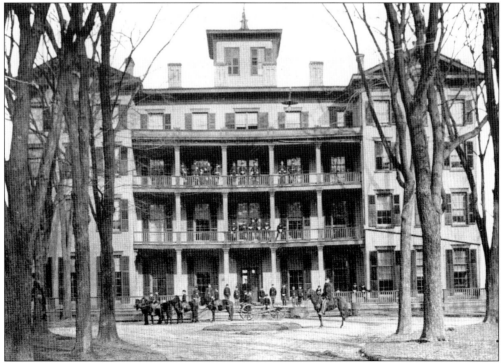

This photograph shows the school when it was the Hudson River Military Academy.

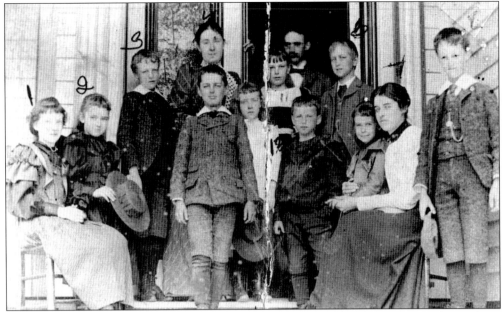

Miss Eleanor Armes's School was on the northwest corner of Voorhis Avenue and Broadway. In this 1895 photograph, the teacher poses with her young students on the porch of the house. Someone numbered the individuals, providing a key to the names on the back: "1 Ann Hodge, 2 Marjorie Oatman, 3 Charlie Steel, 4 Miss Thompson, 5 Dr. Armes, 6 Arthur Aldrich, 7 Miss Armes, 8 Spencer Steel, 9 unidentified, 10 Morton Lexow, 11 unidentified, 12 Annette Carroll, and 13 Stanley Mann."

This is a view of the Miss Leis School.

Liberty Street School superintendent John A. Demarest poses with teachers in 1888. Demarest sits on the porch, and the teachers of the grammar and primary departments are gathered around him.

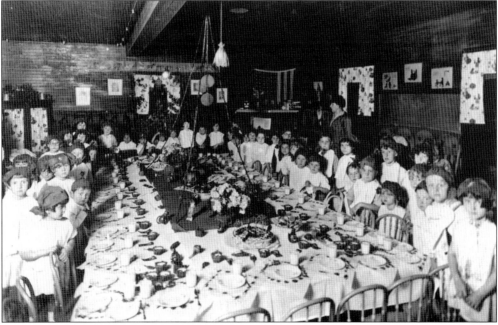

Pictured in 1926, the Bailey School started as a popular boarding school for infants and children in 1921. It became a day school in 1939 for kindergarten and the lower grades. Run by Ella Brandt and her sister, Miss Bailey, it was located in their home at the west end of Brookside Avenue and lasted for about 50 years.

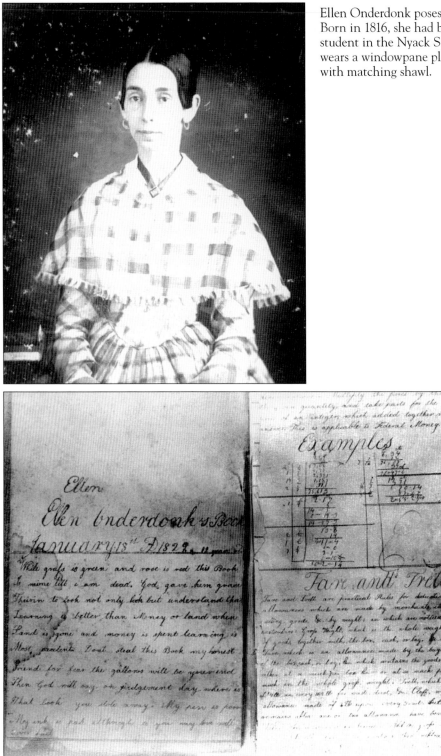

Ellen Onderdonk poses in 1840. Born in 1816, she had been a student in the Nyack School. She wears a windowpane plaid dress with matching shawl.

This school notebook belonged to Ellen Onderdonk.

Carroll S. Waldron poses in his Civil War Zouave uniform against a backdrop of a Civil War camp scene in 1865. On the back of the photograph is written, "A Nyack school boy who was also a boy of '61."

Rev. Archibald Sinclair Stewart poses in 1852. Also called Professor Stewart, he was the Liberty Street School principal in 1852–1853.

Mary J. Tozer began teaching in 1872, the year this picture was taken. Her braided hair is wrapped around her head, and she wears a white-collared dress and strands of beads. Marion Wanamaker, who donated the photograph, wrote on it that Tozer was "easily the greatest teacher the school has ever known."

Eleanor Morison, who began her teaching career in 1859, has her hair arranged in long ringlets, typical of the period. The photograph was taken in 1860.

Teacher Mary E. Sprott is photographed here later in life in 1890. Her high-collared dress has many small pleats in front.

Mary Alling was a young teacher in 1871. She wears her hair in ringlets and has a choker around her neck.

Tunis Depew was a school trustee in 1880 and president of the board of education in 1894. This photograph was taken in 1880.

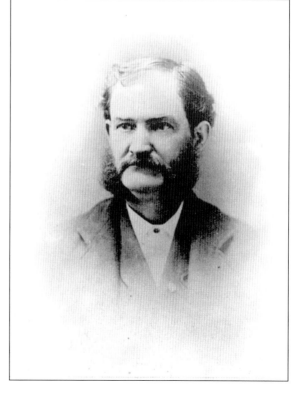

John Blauvelt, trustee, poses in 1880.

Daniel D. Demarest was a school trustee in 1865, the year of this photograph. He was elected treasurer of Rockland County in 1875 and again in 1877. He was the unanimous choice of the Democrats in 1881, and the Republicans did not nominate a candidate. He defeated John H. Blauvelt for the assembly in 1882.

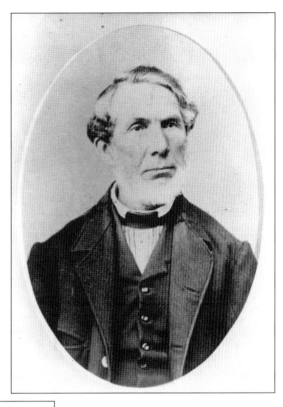

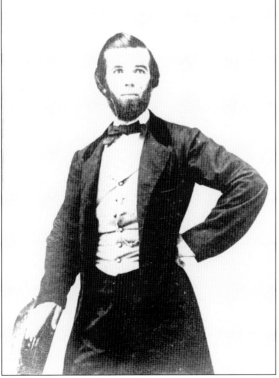

John V. Burr was a school trustee in 1858, the year this photograph was taken.

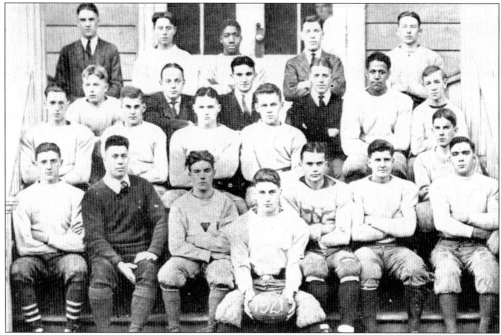

The Nyack High School football team poses for a photograph in 1921.

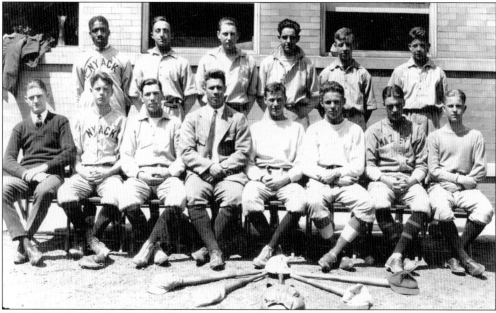

The Nyack High School baseball team is pictured here in 1922.

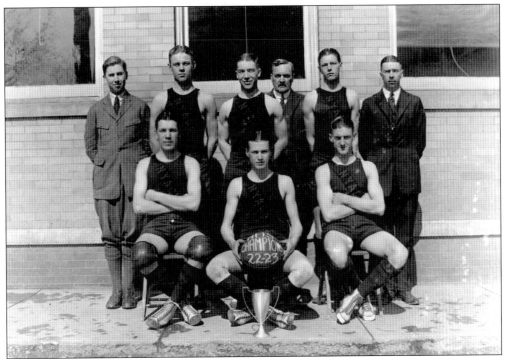

Pictured are the members of the Nyack High School basketball team for the 1922–1923 season.

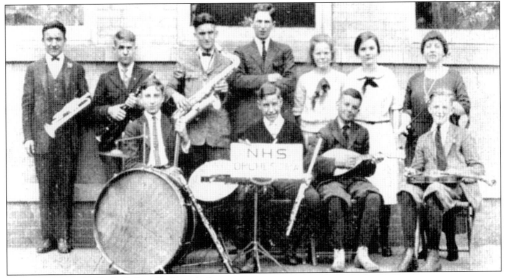

This was Nyack High School's first orchestra.

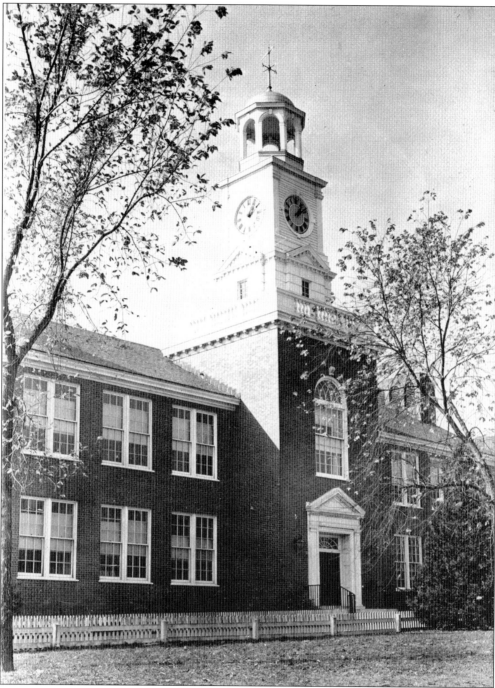

Nyack's $650,000 high school opened in 1929.

Five

HOUSES OF WORSHIP

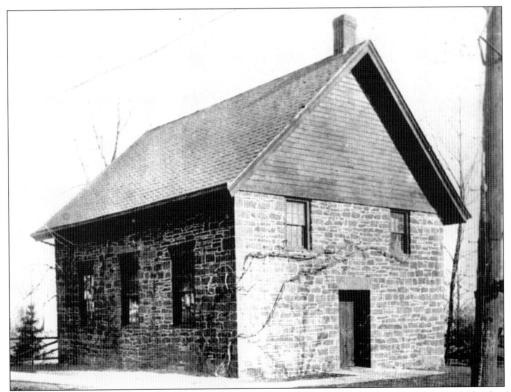

The Old Stone Church, on North Broadway in Upper Nyack, was built in 1813 as a Methodist Episcopal church but has since served other congregations.

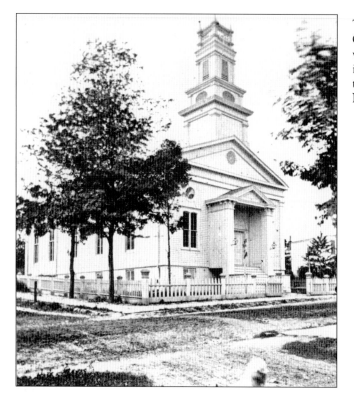

The First Presbyterian Church on South Broadway was built in 1816 and rebuilt in 1899. It was remodeled twice and now serves as the Nyack Center.

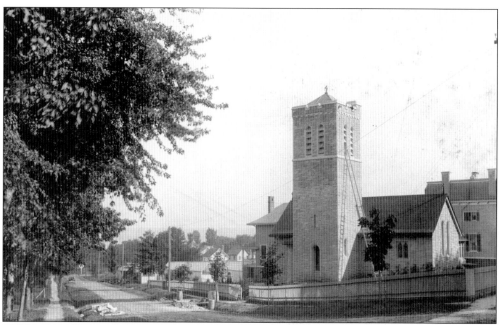

Bell Memorial Chapel, in South Nyack, was demolished for the construction of the Tappan Zee Bridge in 1955.

The Old Reformed Dutch Church was established in Nyack in 1836, enlarged in 1850, and replaced in 1900 by a new building designed by local architect Marshall L. Emery.

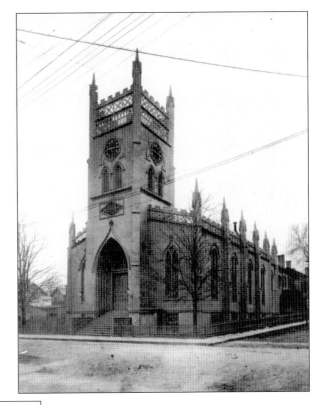

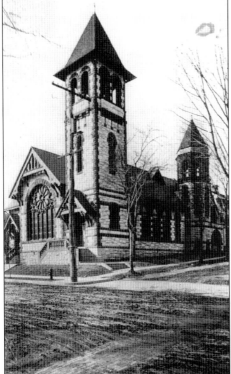

St. Paul's Methodist Church on South Broadway, built in the 1890s, is an outstanding example of Victorian Romanesque style with its massive stone walls, round arches, and distinctive red sandstone trim. It was designed by the Nyack firm of Marshall and Henry Emery.

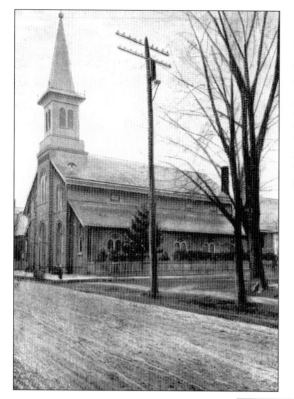

The First Baptist Church was on North Broadway at Fifth Avenue. This brick building was built in 1881 over an earlier one the church had outgrown. It boasted a Tallman Tracker organ that was built in South Nyack and sent to a new home at Chautauqua Institute when the church disbanded in 2000. The steeple was removed in 1926. The founder and first pastor, Elder Joseph Griffiths, was the great-grandfather of 20th-century artist Edward Hopper.

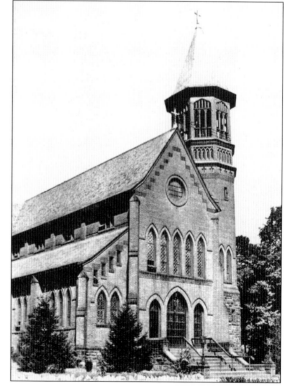

St. Ann's Church was built in 1895 for the Roman Catholic community, which had been present in Nyack since the 1830s. Architect Marshall L. Emery designed this significant late–Gothic Revival building using local materials and workers, except for the stained-glass windows, which came from the Royal Art Establishment of Munich.

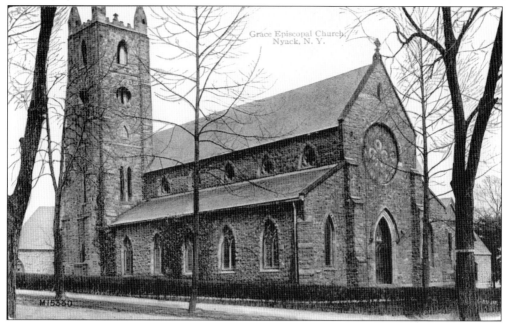

Grace Episcopal Church, dedicated in 1882, was built over a period of more than 10 years. The first rector, Dr. Franklin Babbitt, hired an architect in New York City to design a church based on medieval gothic parish churches in England. It was made of locally quarried traprock and sandstone. Author Washington Irving donated thriving ivy plantings that had been given to him by Sir Walter Scott.

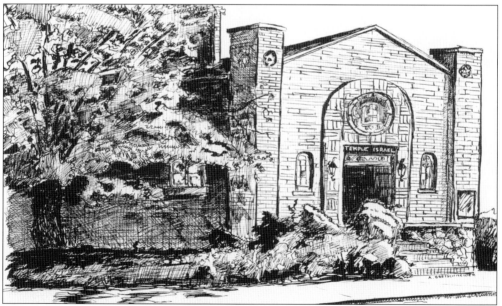

This is an early sketch of the synagogue Temple Israel, on South Broadway at Hudson Avenue. It was dedicated in 1925. It has been the home of Berea Seventh-Day Adventist Church since Congregation Sons of Israel moved to its new home in Upper Nyack in the 1960s. The Congregation of Nyack B'Nai Israel was incorporated in 1891, the oldest continuously operating Jewish congregation in Rockland County.

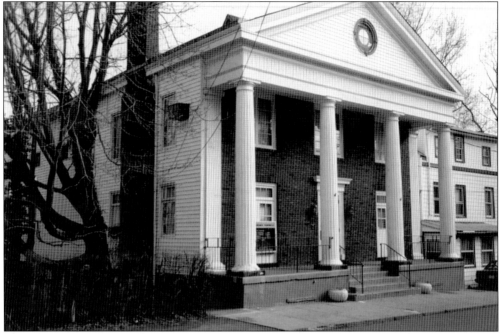

St. John's Deliverance Tabernacle is pictured here on Piermont Avenue in Nyack. The second home of St. Paul's Methodist Church, it became Masonic Hall when St. Paul's moved to South Nyack and was taken over some decades later by St. John's.

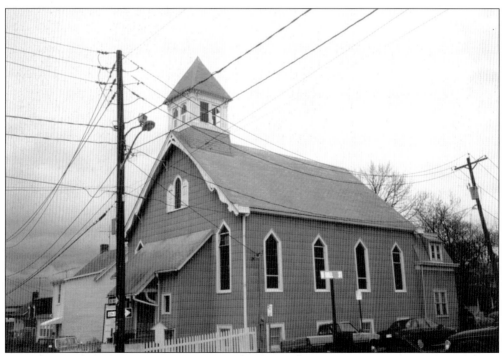

St. Philip's African Methodist Episcopal Zion Church was established at North Mill and Burd Streets in Nyack during the early 1860s.

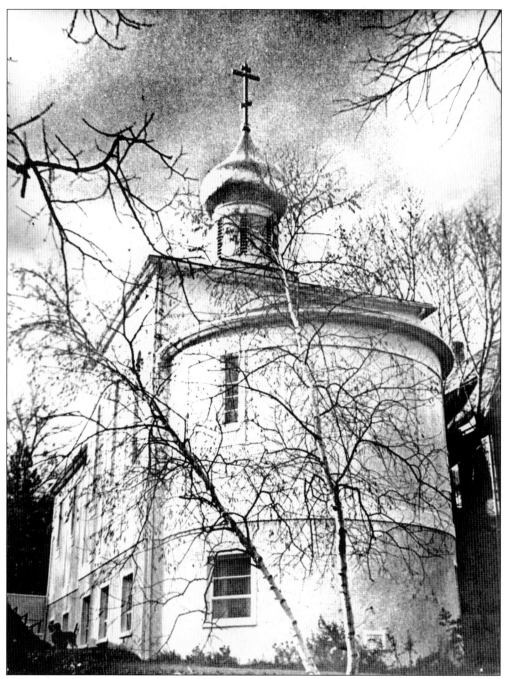

The Russian Orthodox Holy Virgin Protection Church, with its beautiful interior carvings and painted icons, was built in 1957 by Russian emigrant families, many of whom had fled the Communist regime in 1949 to settle in Nyack. The white stucco Byzantine church was later topped with its traditional onion-shaped dome, lovingly hand-covered by women church members with thousands of sheets of genuine 23-karat gold. The dome was designed by Vladimir Tolstoy, grandnephew of Alexandra (youngest daughter of the novelist Leo Tolstoy), who founded the nearby Tolstoy Foundation in Valley Cottage.

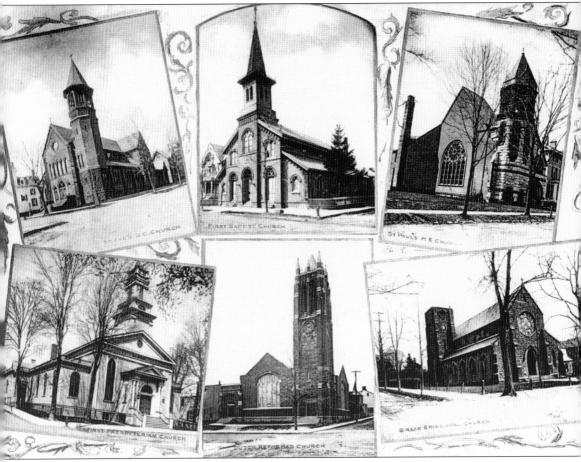

This is a collage of churches in Nyack.

Six

PORTRAITS

On her 89th birthday, noted actress Helen Hayes said, "I have often hoped that there might be a little theater with my name on it in Nyack, the place where I have been happiest for most of my life." With her husband, playwright Charles MacArthur, and their two children, they graciously embraced the community around them, reaching out to neighbors on the street, joining village organizations, and supporting the public schools. A theater on Main Street today bears her name.

Marie Hand was the wife of William Henry Hand.

Pictured is William Henry Hand of South Nyack.

Dr. J. O. Polhemus was a founding trustee of the village and prominent Nyack physician from the 1860s to the 1880s.

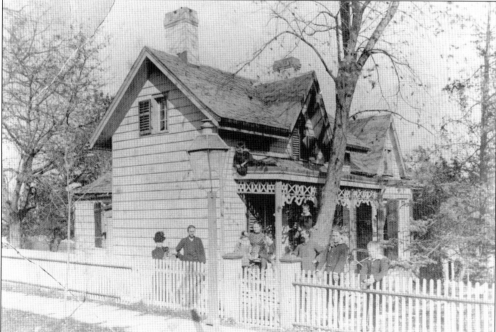

The house at 55 Hillside Avenue in South Nyack is pictured here in the spring of 1888. The residence of Michael and Mary Moynihan Crowley and family, it was destroyed to build the New York State Thruway in 1953.

Lottie Zabriskie Hesselgrave, a properly languid young lady, poses amid the frills and furbelows of Victorian interior decoration.

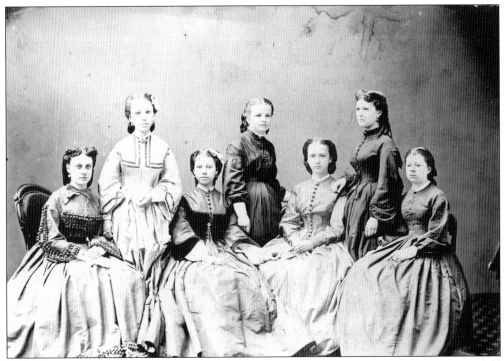

This is a graduating class of the Rockland Female Institute. Opened by the Reverend Mansfield in 1856, the institute stood at the foot of present-day Mansfield Avenue in South Nyack.

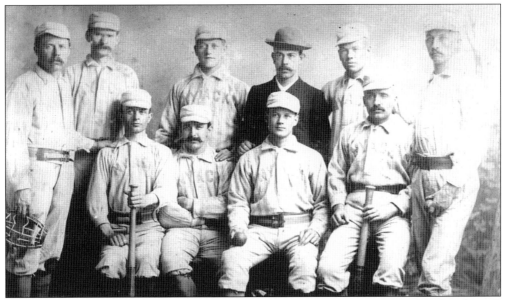

The members of Leitner's Ball Club pose for a photograph. Dr. George Leitner, a founder of Nyack Hospital and a renowned surgeon, had a brilliant earlier career in baseball, first at Fordham and later with the Indianapolis National League team. In the early 1900s, he sponsored a ball club that played on a field adjacent to the hospital on the west side of Midland Avenue. These teams used a nearby barn as a clubhouse, and members paid for their own uniforms, equipment, and travel.

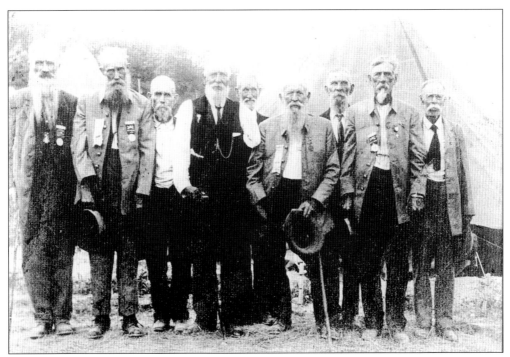

This picture was taken on July 4, 1913, and shows a group of Pickett's Men, survivors of Pickett's charge in Gettysburg in July 1863.

Ralph Owen, age 12 at the beginning of the 20th century, poses with his pooch-powered ice wagon in front of Felter's Ice House at the top of Catherine Street. Workers were happy to give youngsters pieces of ice that broke off from the large cakes they were handling. Ralph in turn sold the pieces given him, the larger ones for 5¢, the smaller ones for 2¢ each.

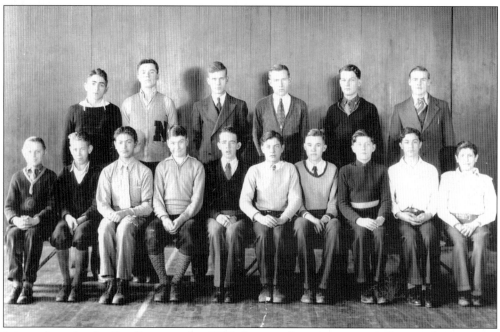

It is unclear why the Boy Scouts in this 1937 photograph are not wearing their uniforms.

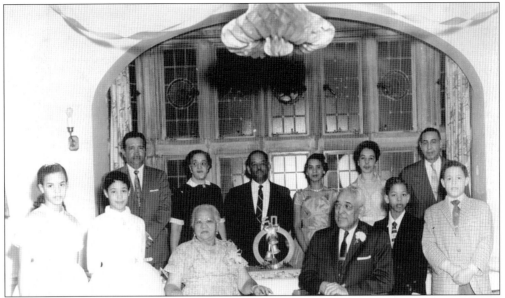

Walter Blount Sr. and his wife moved to Nyack from North Carolina about 1918. Together they ran a busy dry cleaning and tailoring business out of part of their large house at 19 Liberty Street. Blount organized the first chapter of the Rockland NAACP in the 1920s. In 1958, urban renewal swallowed up their property, compensating them only for their home but leaving them without means to reestablish their business. In this photograph, they sit with their large and successful family for a golden wedding anniversary portrait.

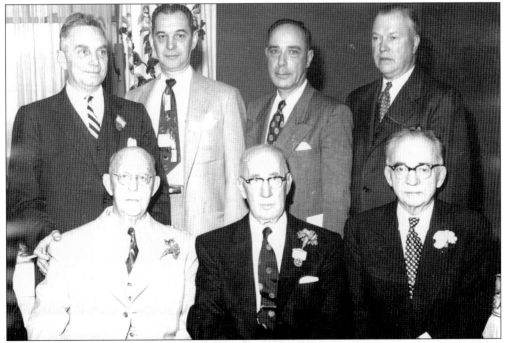

Seven former mayors of Nyack gather for a reunion in February 1955. They are, from left to right, as follows: (first row) Theodore F. O'Dell, Clarence M. Travis, and Oscar Kosel; (second row) John Kilby, J. Henry Mock, Sal Ciancimino, and Edward T. Lovatt.

Nearly every morning for nearly 25 years, a small woman with a carefully folded flag draped over her arm walked from her home on DePew Avenue, bordering Memorial Park, to the pole near the head of the park steps and hoisted the banner with 48 stars. Ella Bohr began her ritual in 1942, when the first of her sons went to war. Three more followed. She said she wanted some special way of showing pride in them. At the end of the day, she would return to take the flag down.

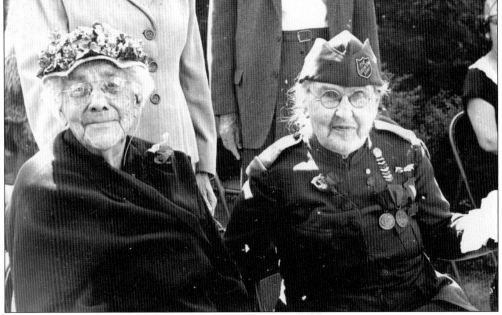

Pictured are Mary Halliday (left) and Alice Waldron. Halliday, mother of eight children, lived almost 103 years. Her father and his five brothers all served in the Union army in the Civil War. She worked as a maternity nurse in the community and was active in the Women's Relief Corps and many other women's community organizations. Waldron's father was an Andersonville prisoner. The Grand Army of the Republic post in Nyack was named for him. As a recruit in the Salvation Army, Alice Waldron went to war also, joining American forces in France during World War I and setting up canteens close to the front lines. At her death, she was buried with special military honors.

In 1929, Virginia Parkhurst arrived in Nyack, a town she had never heard of, to take a newspaper job at the *Journal News*. By the time she retired, she had reported skillfully on the lives and events of its inhabitants for 45 years and was appointed village historian. Her editors at the *Journal News* knew her as "a petite lady with consummate class and a firestorm at the typewriter."

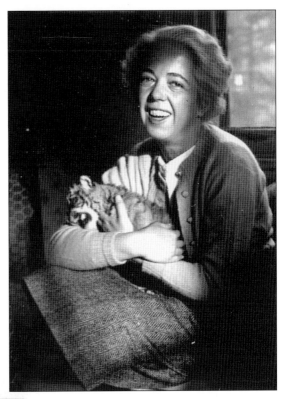

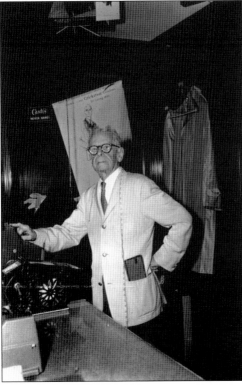

James Zabriskie worked in the men's clothing store at 9 North Broadway for 72 years, retiring just two years before his death. In his teens, he quit school and went to work for the original owners, Smith-Quidor, for $2.50 a week and became owner in 1912. The store was open from 7:00 a.m. to 9:00 p.m., including Sundays, until he and his competitor around the corner at Neisner's bought cars and agreed to close shop so they could enjoy them.

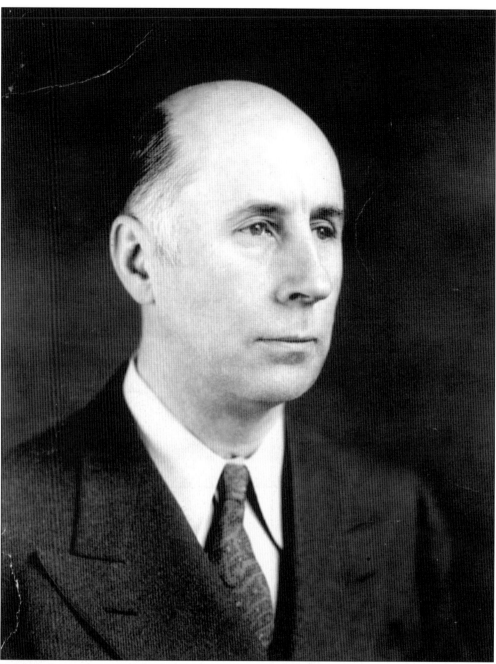

Pierre A. Bernard, an astute businessman, guru, and something of a charlatan, had great personal charisma. He is probably best known for his claim of pioneering the knowledge and practice of yoga in the United States. He founded the Clarkstown Country Club, "a unique club dedicated to translating the business of living into an art." The art was emphasized by his wife, Blanche de Vries, who largely ran the growing operation and performed in many of its dances and plays. The club attracted first-class performers and an eminent clientele. Bernard bought land and buildings in Nyack, and the club thrived until personal problems and ill-advised investments caused a rapid decline in its fortunes.

Seven

CLARKSTOWN
COUNTRY CLUB

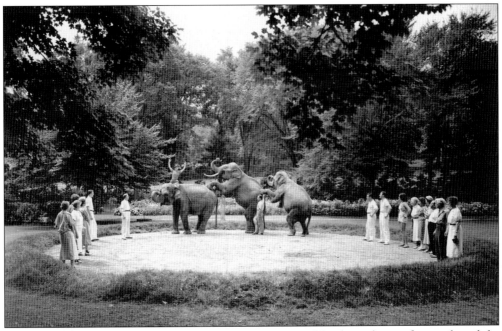

The Clarkstown Country Club was an exotic import to Nyack, and its influence lasted for decades, though its members rarely mingled with the local residents. Home to eight elephants, a llama, and peacocks, as well as six tennis courts, indoor and outdoor swimming pools, gardens, a cabin cruiser for trips on the Hudson, and eventually even a sports stadium, it catered to the wealthy who came for art, culture, fun, self improvement, and rehabilitation. Its circus tent was the largest in the country.

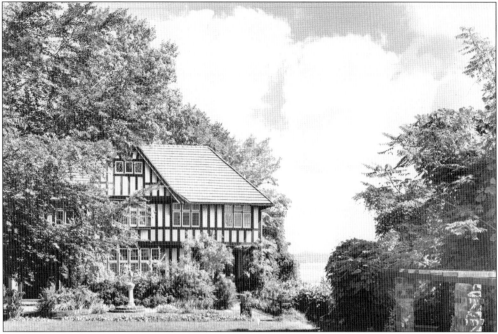

The Moorings, pictured in 1931, was a large Tudor building on a hill near the Hudson, then owned by the Clarkstown Country Club.

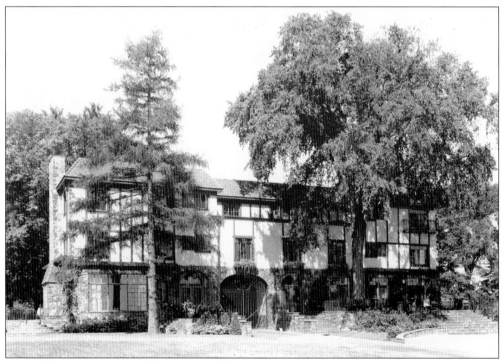

The Clarkstown Country Club's main clubhouse, pictured in 1934, later became Mosley Hall of Nyack College.